IMAGES
of Rail

RAILROADS OF
CAPE COD AND THE ISLANDS

OLD COLONY R.R

CAPE COD DIVISION.

BOSTON STATION, CORNER SOUTH AND KNEELAND STREETS.

TIME TABLE FOR PASSENGER and MIXED TRAINS.

Takes effect SUNDAY, SEPT. 25, 1887.

(DOWN.) **CAPE COD TRAINS.** (UP.)

WEEK-DAYS.

All Trains will discontinue stopping at Onset Bay and after October 4th. A Will stop to leave passengers from below Buzzards Bay and Fairhaven Branch.

(DOWN.) **FAIRHAVEN BRANCH TRAINS.** (UP.)

WEEK-DAYS.

(DOWN.) **WOODS HOLL BRANCH TRAINS.** (UP.)

WEEK-DAYS.

See Special Poster for Time of Vineyard and Nantucket Boats.

C. H. NYE, Division Sup't. **J. R. KENDRICK, Gen. Manager.**

HYANNIS, MASS. **GEO. L. CONNOR, Gen'l Pass. Agent.**

A CAPE COD DIVISION TIMETABLE, SEPTEMBER 25, 1887. The Old Colony Railroad operated the Cape rail lines between 1872 and 1893, when it became a part of the New York, New Haven and Hartford Railroad. This timetable poster lists the schedule of Old Colony trains between Boston and Provincetown, along with the Fairhaven branch and the "Woods Holl" branch. Note the absence of the Chatham branch, which did not open until November 22, 1887. (Courtesy of William Reidy.)

2

IMAGES
of Rail

RAILROADS OF
CAPE COD AND THE ISLANDS

Andrew T. Eldredge

ARCADIA

First printed in 2003.

Published by Arcadia Publishing,
an imprint of Tempus Publishing Inc.
2A Cumberland Street
Charleston, SC 29401

Printed in Great Britain.

Library of Congress Catalog Card Number: 2002114121

For all general information, contact Arcadia Publishing:
Telephone 843-853-2070
Fax 843-853-0044
E-mail sales@arcadiapublishing.com

For customer service and orders:
Toll-free 1-888-313-2665

Visit us on the Internet at www.arcadiapublishing.com.

On the cover: **THE DAY CAPE CODDER.** With New Haven Railroad I-2 Pacific locomotive No. 1334 in the lead, the *Day Cape Codder* has just departed Woods Hole, destined for New York. (Courtesy of Philip H. Choate.)

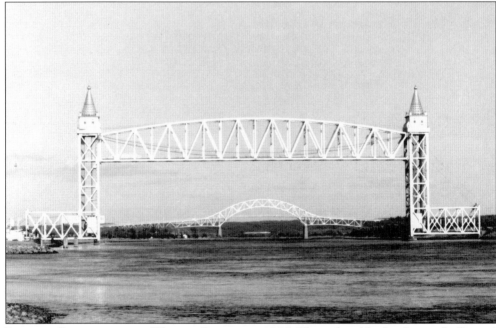

LOOKING SPLENDID IN THE WINTER SUNSHINE, 1984. The railroad bridge frames the Bourne highway bridge on a peaceful February day. (Photograph by William Reidy.)

CONTENTS

ACKNOWLEDGMENTS

I am indebted to my parents, Marilyn Fifield and Richard O. Eldredge, for chasing trains and encouraging my rail interest throughout my life and, most recently, for their assistance in the process of compiling this book. This publication itself is a tribute to all who contributed, but especially to Howard Goodwin, who generously shared both his extensive knowledge of rail history and his impressive personal collection of historic postcards and photographs. In addition, I deeply appreciate vital contributions of expertise and photographs from all of the following individuals: Philip H. Choate, Herb Clark, Kevin T. Farrell, Robert Farson, Robert Fifield, John Kennedy, Michael O'Connor, William Reidy, Dave Santos, Doug Scott, Allen F. Speight, and Robert Thompson. For research assistance and access to archives, special thanks are due to Barbara Gill of the Sandwich Archives; Pat Margolies of the Bourne Historical Archives; Mary Sicchio, Nickerson Room librarian at Cape Cod Community College; and editor David Still II and the staff of the Barnstable Patriot.

INTRODUCTION

From its 1848 arrival in Sandwich, the railroad has played a varied and vital role on Cape Cod and the islands of Nantucket and Martha's Vineyard. For 50 years, between 1887 and 1937, the railroad ran to 14 of the 15 Cape towns (skipping only Mashpee), with 94 miles of track connecting Buzzards Bay and Woods Hole with Hyannis, Chatham, and Provincetown. The tracks even extended onto wharfs in Woods Hole, Hyannis, and Provincetown for convenient transfer of passengers and freight between rail and ship for passage between the Cape and the islands. Martha's Vineyard had nine miles of track providing summer rail passenger service for 20 years, from 1876 to 1896. Nantucket had as much as 10 miles of rail for summer passengers over 34 years, between 1884 and 1918. In four decades of railroad expansion on the Cape, the population consistently declined, from 35,276 in 1850 to 29,172 in 1890. The exodus of Cape Codders persisted until the automobile began offering independence from the train schedule, and the 1930 U.S. Census reported a population of 32,305.

By 1940, the seven-mile Chatham branch (the last Cape rail added, in 1887) had already been abandoned, leaving 86 miles of Cape track in passenger service (a number that dropped substantially after the discontinuance of scheduled passenger service beyond Yarmouth). During World War II, the train served to transport troops at Camp Edwards and Camp Wellfleet, reminiscent of its service in World War I, when it also hauled artillery intended to protect Provincetown.

Active rail lines were cut by more than half before the decade's end, to leave just 41 miles in passenger service (none beyond Yarmouth) by 1950, while the Cape population continued to climb and vacationers flocked to savor the rural seaside charm of the Cape and the islands.

A decade later, regular Cape passenger rail service had ended (in 1959), severing the Cape's reliable lifeline with the mainland just when the Cape Cod National Seashore was created (in 1961) to offer seaside recreation to the urban Northeast, with two and a half million annual visits projected. The New Haven Railroad resumed summer service from New York in 1960, but that only continued through the 1964 season.

By 1970, the region's railroads that had helped foster tourism by providing reliable transportation for visitors and for the goods to fuel the growing regional economy had been reduced to 38 miles of Cape track in freight service connecting Buzzards Bay, Falmouth, Hyannis, and South Dennis, but with no passenger service. The Cape population had more than doubled since 1950 to reach 96,656 by 1970.

Despite determined regional efforts in the 1970s and early 1980s to preserve remaining

freight service and to restore passenger service, by the early 1990s Cape rail service was primarily limited to hauling solid waste off-Cape to the SEMASS waste-to-energy incinerator at Rochester, Massachusetts.

Efforts to revive the popular Cape Cod and Hyannis Railroad passenger service that operated between 1981 and 1989 were stymied. The service connected Hyannis and Falmouth with Boston via a transfer at Braintree to the MBTA Red Line, and it also met Amtrak at Attleboro.

By 2000, there were a quarter of a million Cape and island residents, and the region's growth rates have led the state for decades. The Cape Cod National Seashore annually attracts some five million visits, double the number projected at its inception. However, rail service in the three-county region is limited to the Cape's daily trash hauling, plus three-season passenger excursions and upscale dinner trains on 23 miles of track (just one-quarter of the Cape track mileage in service during its 50-year peak between 1887 and 1937).

In more than a century and a half since these historic tracks came to the Cape in 1848, they have conveyed freight, both inbound and outbound, as well as an untold procession of celebrity visitors. These notables included writer and environmentalist Henry David Thoreau, one of the Cape's earliest rail travelers in 1849; *America the Beautiful* author Katharine Lee Bates, who returned each summer from Wellesley to vacation in her native Falmouth; New England orator Daniel Webster, who enjoyed Cape hunting; and the Joseph P. Kennedy family, who summered in Hyannis Port. Cape rail served the nation in wartime as well, hauling Camp Edwards troops and Provincetown artillery in World War I, Camp Edwards and Camp Wellfleet troops in World War II, and Otis Air Force Base missiles in the cold-war years of the 1960s.

The future role of Cape Cod's historic rail infrastructure remains in question. Will the rail right-of-way that has served the area for more than 150 years (importing sand and fuel for glassmaking, exporting products such as salt and fish, and easing the economic transition from fishing and manufacturing to tourism) sustain the priceless national treasure of Cape Cod and the islands in the years to come? Will it ease the region's legendary traffic congestion and lessen the increasing threat of air pollution?

On June 22, 2001, Michael S. Dukakis—former Massachusetts governor, 1988 Democratic presidential candidate, and then acting chairman of the Amtrak board of directors—addressed the annual banquet of the Cape Cod Chapter of the National Railway Historical Society. Vintage posters were on display, depicting the venerable Budd cars that had plied Cape rails and were proposed for return some 40 years later for 21st-century restoration of Cape Cod passenger rail service.

The front page of the *Cape Cod Times* the following day included this excerpt from staff writer Eric Williams's account of the event: "'Does the Cape need rail?' asked Dukakis. 'Is there any question about that? We're not going to build highways to get out of this.' Dukakis said he was concerned about transportation pressure on the peninsula. 'I love the Cape. It's being overwhelmed. The pressure on this special place is going to continue. Rail service will help people enjoy this place and not destroy it.'"

In his new book *Becoming Cape Cod: Creating a Seaside Resort*, James O'Connell concludes, "Cape Cod's future is up to its residents. Will they have the will and vision to preserve its wonders, to keep it a special place?"

In pondering that question, all who value Cape Cod and the islands should consider how significant rail could be in sustaining this treasured region by easing traffic congestion and air pollution while improving the mobility of millions of residents and visitors. We should also urge our leaders to have the "will and vision" to restore the rail service the Cape enjoyed some 40 years ago, when the population was one-third its present size and the draw of the Cape Cod National Seashore was but a dream.

One

BUZZARDS BAY
TO HYANNIS

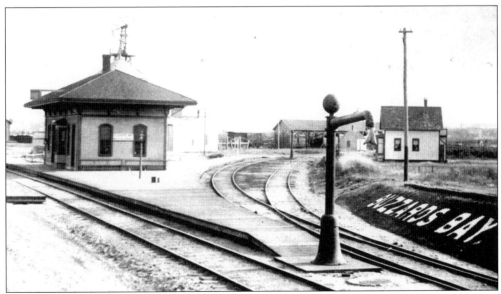

BUZZARDS BAY, 1871. This station was named Cohasset Narrows until August 1, 1879, when it was renamed Buzzards Bay. In 1872, an interlocking tower was constructed here, along with the completion of the new branch to Woods Hole. The tracks to the left in this photograph are the main line to the Cape. The tracks to the right are only yard tracks, although the Woods Hole branch later joined here. (Courtesy of Howard Goodwin.)

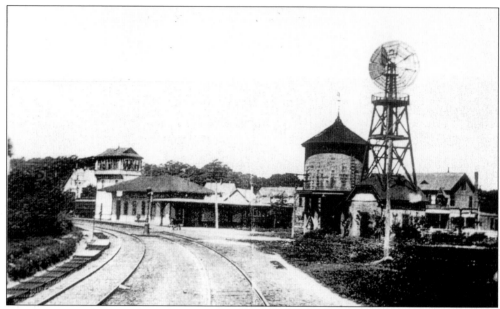

BUZZARDS BAY, THE EARLY 1900S. This view looks up the Woods Hole branch toward the station and junction with the Cape main line. The pipes to the left of the second track run up to the interlocking tower and through a system of levers to control the track switches and semaphore signals at Buzzards Bay. (Courtesy of Howard Goodwin.)

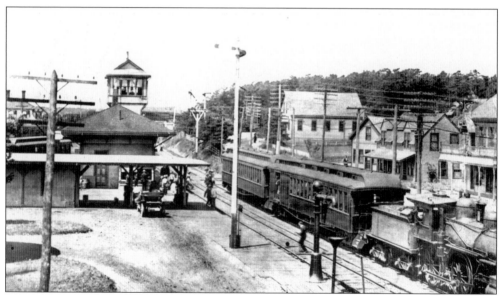

BUZZARDS BAY, 1908. This photograph shows how the line to Woods Hole branched off the main line to Hyannis and Provincetown at Buzzards Bay. The Hyannis-Provincetown line is to the right. To the left of the station is a train on the Woods Hole branch. Although there was no moveable bridge to control, the interlocking tower was in control of all the track switches and semaphore signals at the junction of the two lines. The tower was replaced in 1911 with a concrete one still in use today. (Courtesy of Howard Goodwin.)

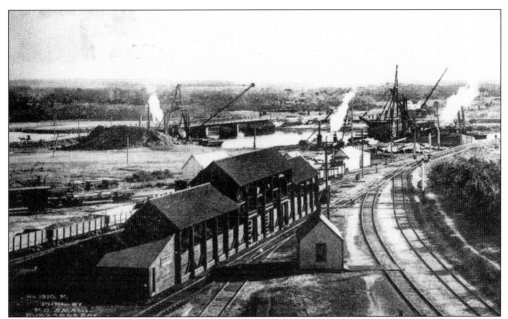

BUSTLING BUZZARDS BAY, 1909. In this view of the Monument River, construction of the new bascule bridge is under way. Next to the Shore Road bridge across the river, a dredge is working on widening and deepening the river in preparation for the canal. To get this equipment into the Monument River, the railroad temporarily removed a part of its bridge on the Woods Hole branch and then promptly replaced it once the machinery was on the other side. (Courtesy of Howard Goodwin.)

RAILROAD BRIDGE CONSTRUCTION, 1910. Before the construction of the Cape Cod Canal, the railroad crossed the Monument River on fixed trestles, including the one pictured here. The train on the trestle (on the Woods Hole branch) is delivering steel for the construction of the new bascule bridge. The bridge was completed in September 1910. However, due to a delay in relocating the tracks on both sides, it was not used for rail movement for at least another year. (Courtesy of Howard Goodwin.)

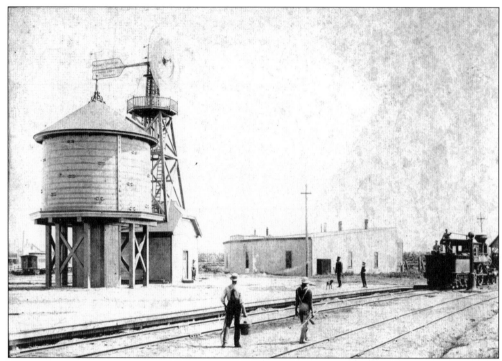

Buzzards Bay, the Early 1900s. A 4-4-0 American-type locomotive is taking on water at Buzzards Bay in this rare view that includes the enginehouse. Interestingly, Buzzards Bay never had a turntable, but there was a wye track that could be used to turn entire trains. (Courtesy of the Bourne Archives.)

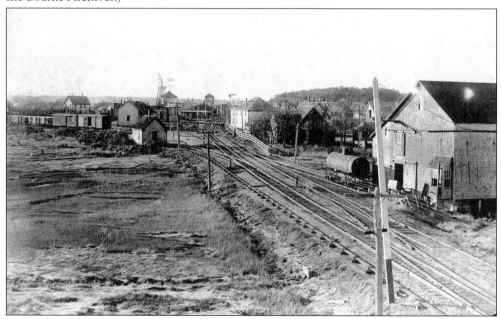

Buzzards Bay, the Late 1800s. This view looks up the Cape main line toward the station at Buzzards Bay. The windmill, water tank, and interlocking tower can be spotted in the distance. (Courtesy of the Bourne Archives.)

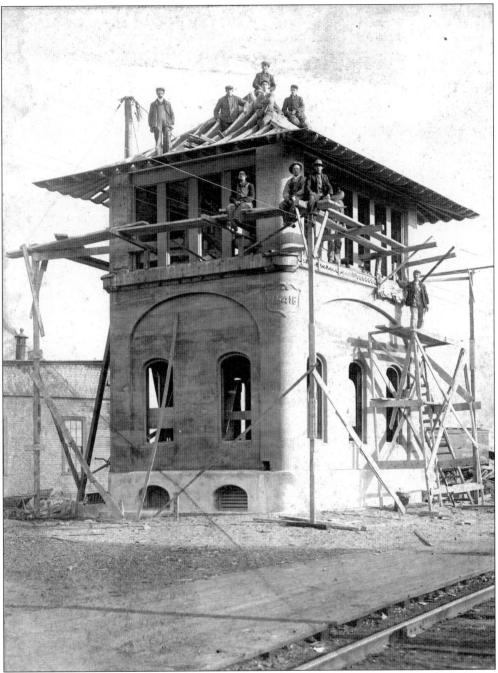

TOWER CONSTRUCTION AT BUZZARDS BAY, 1911. Workmen pose for a photograph during construction of the interlocking tower. The tower still controls daily train movements. (Courtesy of the Bourne Archives.)

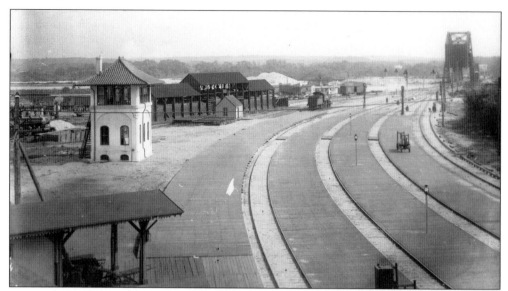

THE CHANGING FACE OF BUZZARDS BAY, 1911. The completed interlocking tower at Buzzards Bay was in use by the time this photograph was taken. The new bascule bridge across the Cape Cod Canal was also in service. However, construction of the passenger station to replace the one built in 1870 had yet to begin. (Courtesy of the Bourne Archives.)

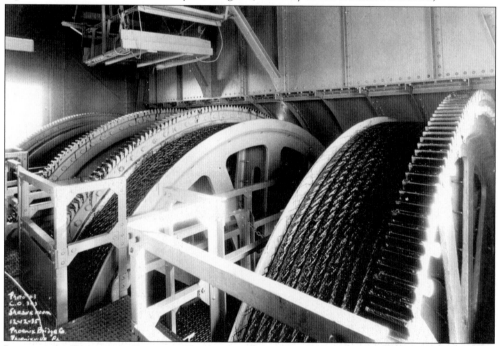

INSIDE THE RAILROAD BRIDGE. The vertical-lift railroad bridge at Buzzards Bay was built between 1933 and 1935 at a cost of more than $1.5 million. The moveable span of 544 feet provides a vertical clearance of approximately 136 feet above mean high water when raised, and only about seven feet when lowered for a rail movement. This photograph shows the gigantic 16-foot-diameter sheaves (four in each tower) that carry the cables connecting the moveable span and counterweights. (Courtesy of William Reidy.)

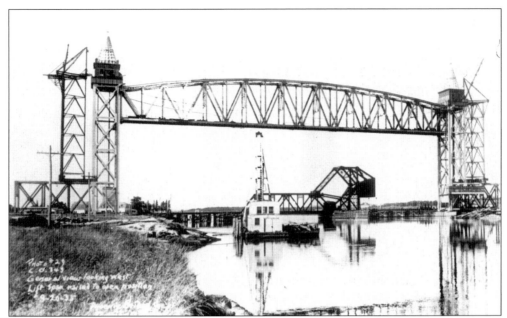

CONSTRUCTING THE BRIDGE, SEPTEMBER 20, 1935. The Buzzards Bay vertical-lift bridge was the longest in the world until it was surpassed in 1959 by a bridge on Staten Island. The bridge still sees regular railroad service six days a week. This Phoenix Bridge Company photograph shows the new bridge under construction, with the old still in use beyond. A little over three months after this photograph was taken, the new bridge saw its first train. (Courtesy of Howard Goodwin.)

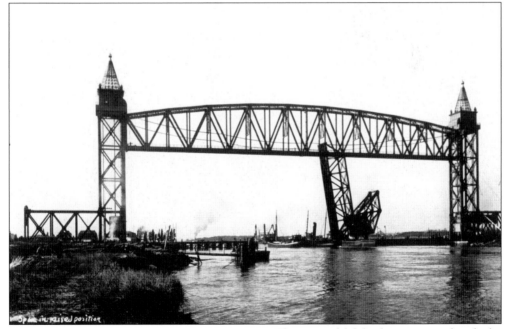

THE NEW AND THE OLD, NOVEMBER 27, 1935. The vertical-lift bridge is pictured with the bascule bridge it replaced. The new bridge is nearly complete but not yet in service. (Courtesy of the Bourne Archives.)

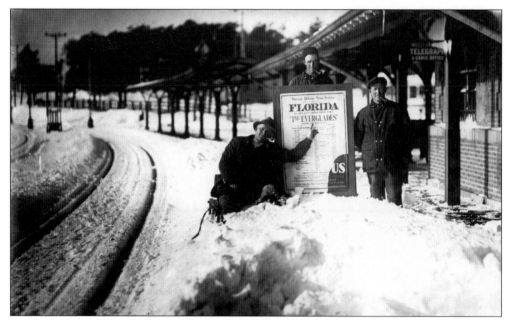

FLORIDA, ANYONE? After a 1925 snowstorm, railroad workers pose with an advertisement for a special train to Florida. Called the *Everglades,* it was billed as a deluxe through-train, operating from Boston to Miami daily. (Courtesy of the Bourne Archives.)

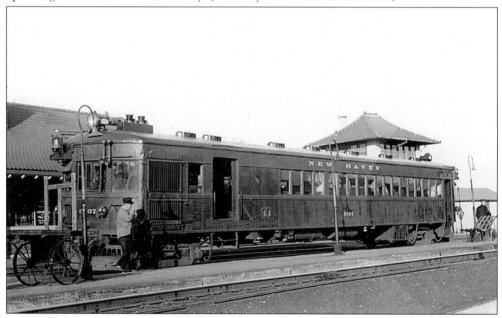

A NEW HAVEN GAS-ELECTRIC CAR. The advent of the automobile brought about a decline in branch-line passenger traffic, which caused conventional trains (with their five-man crews and steam locomotives) to become economically unviable. By the mid-1930s, the New Haven Railroad had acquired a total of 15 of these Brill Model 250 gas-electric rail cars, including No. 9107, seen here at Buzzards Bay. These self-propelled cars employed a 250-horsepower gasoline engine that (connected to a generator) produced electricity to turn two traction motors mounted beneath the car. This car remained in service until 1950. (Author's collection.)

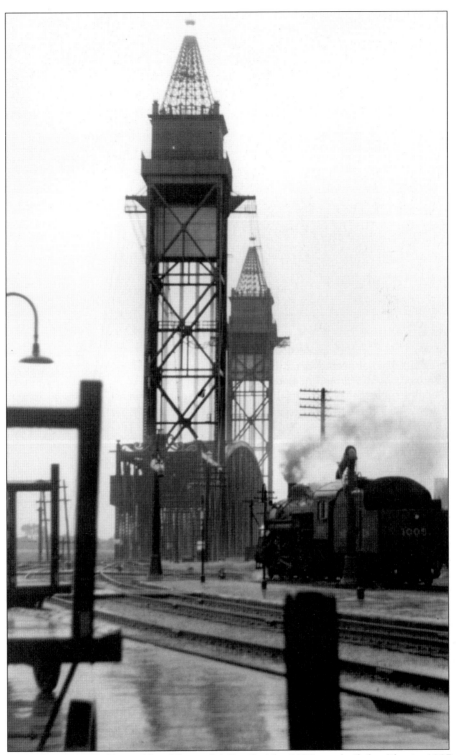

BUZZARDS BAY IN THE RAIN. New Haven I-1 Pacific No. 1005 was built by Alco in 1907 and remained in service until 1950. (Courtesy of William Reidy.)

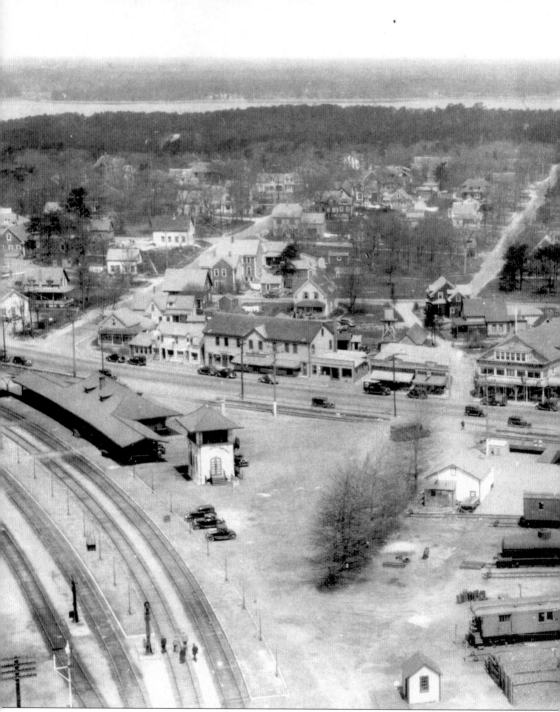

AN AERIAL VIEW OF BUZZARDS BAY, 1937. This view from the north tower of the Buzzards Bay railroad bridge shows Buttermilk Bay in the background. The freight house, with a platform several car-lengths long, is near the center. Although most of the railroad facilities pictured

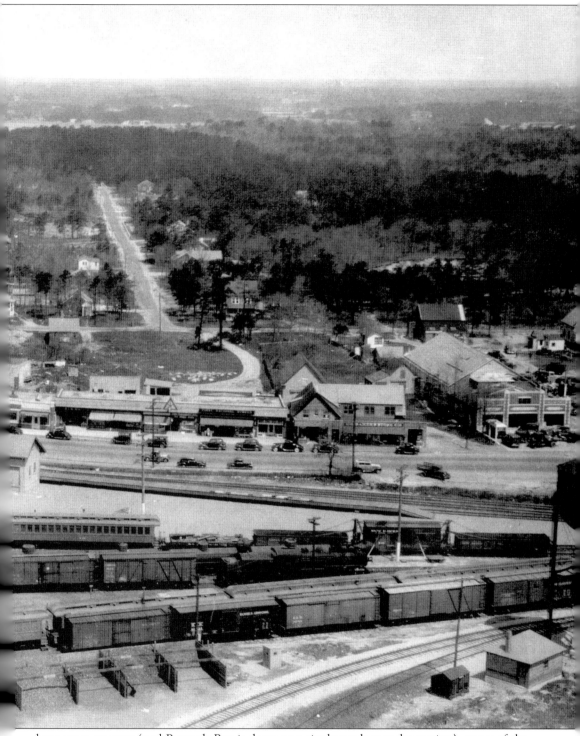

here are now gone (and Buzzards Bay is down to a single track past the station), many of the other buildings in the village survive. (Courtesy of Herb Clark.)

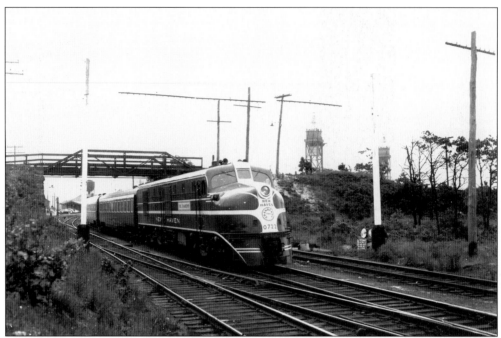

THE CRANBERRY DEPARTING BUZZARDS BAY. From 1949 through 1953, Alco DL-109 No. 0722 was painted into a special red-and-white paint scheme. It was most often found leading the *Cranberry*, a Boston-to-Hyannis train. In this view, the Buzzards Bay station and railroad water tower can be seen in the background, along with the railroad bridge across the Cape Cod Canal. Note the "telltale" (the wires suspended between the two white poles), which served to alert any crew members atop the trains of an impending low clearance (in this case, the Taylor Avenue overhead bridge). (Courtesy of William Reidy.)

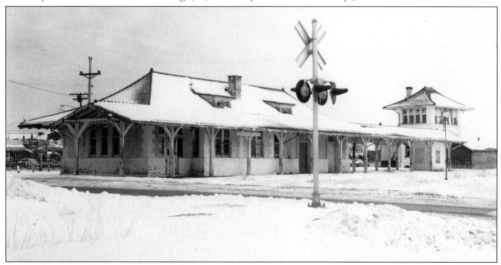

BUZZARDS BAY IN THE SNOW, JANUARY 1977. With most of its tracks removed, part of its canopy gone, and the crowds of people it welcomed now just a memory, the Buzzards Bay station still looks good after a fresh snowfall. Today, this view remains virtually unchanged, as the station still stands (currently housing the Canal Region Chamber of Commerce). (Courtesy of Howard Goodwin.)

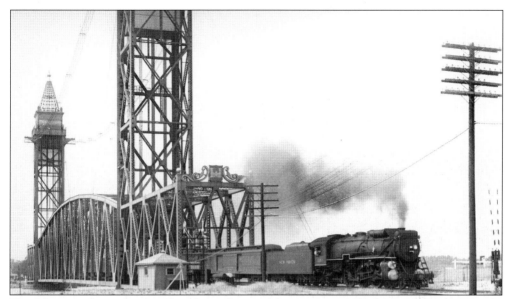

THE HYANNIS SECTION, THE *DAY CAPE CODDER*, JULY 9, 1939. With New Haven I-4 Pacific No. 1357 in the lead, the Hyannis section of the *Day Cape Codder* is off and running for the final 24 miles of its journey. Just minutes before this photograph was taken, the two sections of this train had been one, but they were split in two on the other side of the canal at Buzzards Bay after arriving from New York. (Courtesy of Howard Goodwin.)

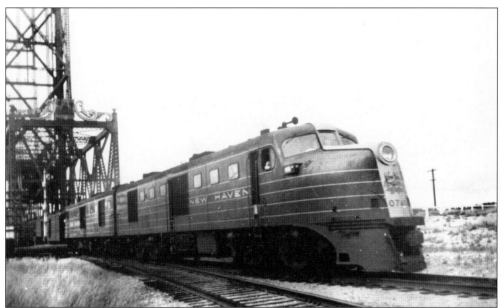

HEADING FOR HYANNIS, AUGUST 1946. A pair of New Haven Alco DL-109s, with No. 0742 in the lead, head for Hyannis. This Canal Junction photograph was taken at the foot of the railroad bridge. (Courtesy of Howard Goodwin.)

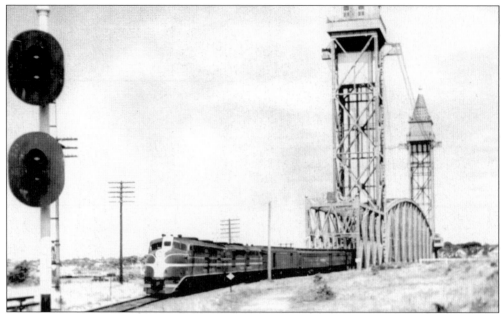

THE DAY CAPE CODDER, AUGUST 31, 1952. Two Alco DL-109 locomotives lead this section of the *Day Cape Codder*. Just moments before this photograph was taken, on the other side of the bridge at Buzzards Bay, this train was split into two sections, with one headed to Woods Hole and this one to Hyannis. The train originated earlier in the day in New York. At this location, it was only 24 miles from its destination. (Courtesy of Howard Goodwin.)

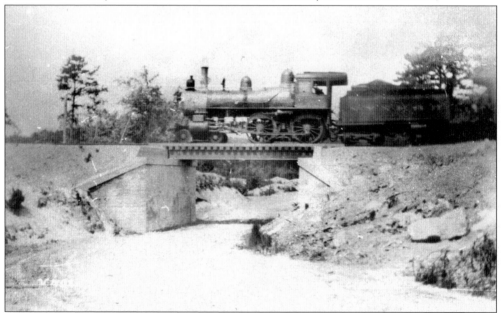

A STEAM LOCOMOTIVE AT APTUXCET. This view of the under-grade bridge leading into the historic Aptuxcet Trading Post, less than a half-mile from the railroad bridge, remains virtually unchanged, although finding a 4-4-0 steam locomotive there to re-create this photograph is unlikely. The train pictured here is headed for the bridge and Buzzards Bay. (Courtesy of Howard Goodwin.)

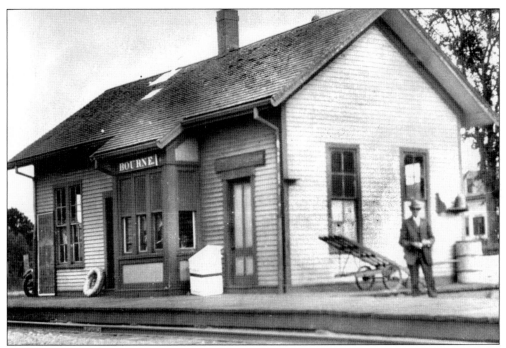

THE BOURNE STATION, 1926. This Bourne station (formerly called Monument) was originally on the opposite side of the Monument River in Bourne but was moved before canal construction was under way in the early 1900s. It originally stood near the mainland side of today's Bourne highway bridge. (Courtesy of the Bourne Archives.)

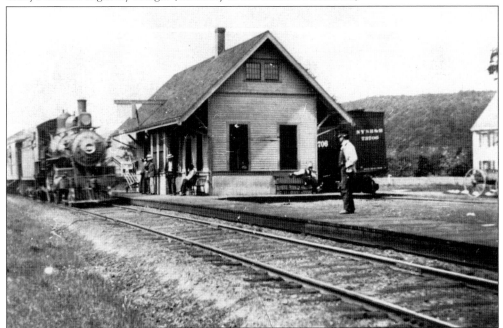

THE BOURNEDALE STATION. This station at Bournedale was originally called North Sandwich. After the construction of the canal, a small ferry was provided to the station for residents who lived on the opposite side. (Courtesy of the Bourne Archives.)

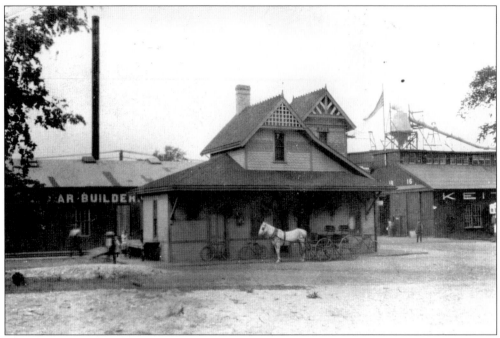

THE SAGAMORE STATION, 1900. The street side of the Sagamore station is seen here, with the bustling Keith Car and Manufacturing Company in the background. Plymouth Street is to the right, crossing the tracks. This unique station was constructed in the mid-1880s and was used until it was replaced in 1912. (Courtesy of Howard Goodwin.)

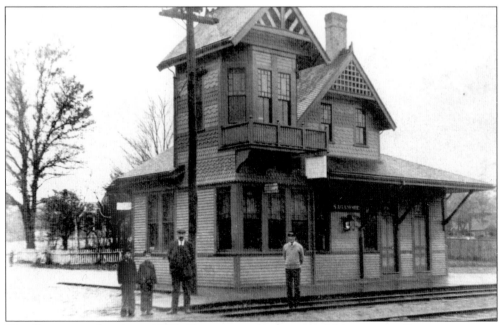

THE SAGAMORE STATION, 1905. Here is a trackside view of the two-story Sagamore station. The second story housed offices for the Keith Car and Manufacturing Company. (Courtesy of Howard Goodwin.)

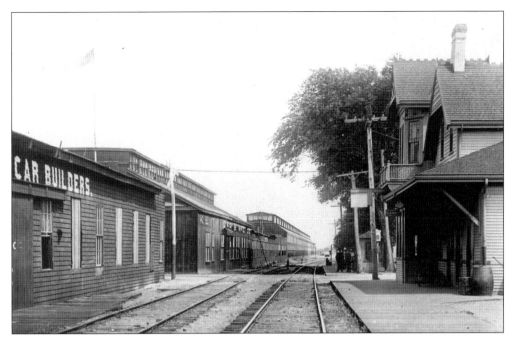

THE SAGAMORE STATION AND THE KEITH PLANT, 1909. At the time this photograph was taken, the old Sagamore station, built in the mid-1880s, was still in service, and Keith was as busy as ever, although business further increased during World War I. The crossing just after the station, leading into the Keith plant, is Plymouth Street. (Courtesy of Philip H. Choate.)

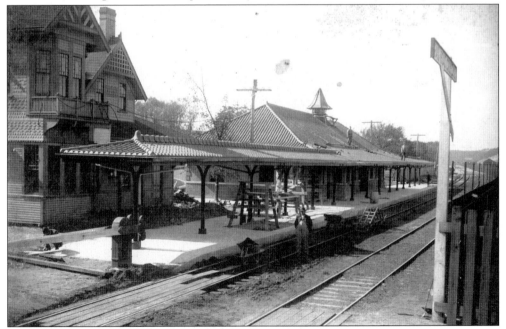

TWO ERAS AT SAGAMORE, 1912. This photograph, taken from the Keith plant, shows construction progressing on the new station at Sagamore, with the old station still standing behind. The new station probably opened shortly after this photograph was taken. (Courtesy of the Bourne Archives.)

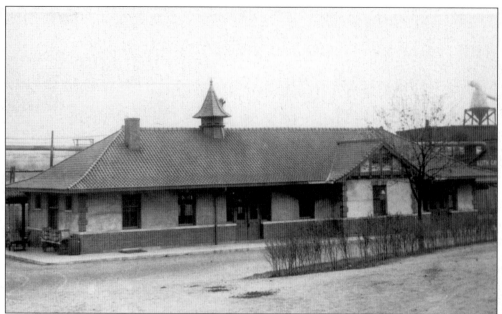

THE NEW SAGAMORE STATION, 1912. The Keith plant was still a very busy place when this photograph was taken. The station is architecturally similar to the New Haven stations at Buzzards Bay and West Barnstable. Unlike those two, however, this one no longer stands. (Courtesy of Howard Goodwin.)

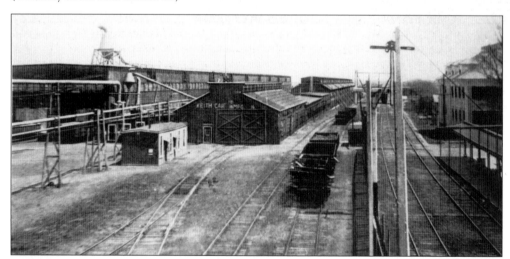

KEITH CAR AND MANUFACTURING, 1914. This view shows how expansive the Keith works site was. The company started out in 1829, producing items such as carts, wagons, wheelbarrows, and tools. It also manufactured Conestoga wagons and prairie schooners. When the Cape Cod Branch Railroad decided on a route that happened to run right beside the Keith plant, a siding was constructed through the main building. By the 1870s, nearly everything produced at the plant was for the railroads. The company continued to produce all types of railroad freight cars until 1928, when the plant was bought by the Pullman Company and shut down. A few years later, the federal government purchased the property and demolished the remaining buildings to make way for a wider Cape Cod Canal. The company was in business at Sagamore in one form or another for 99 years. (Courtesy of Howard Goodwin.)

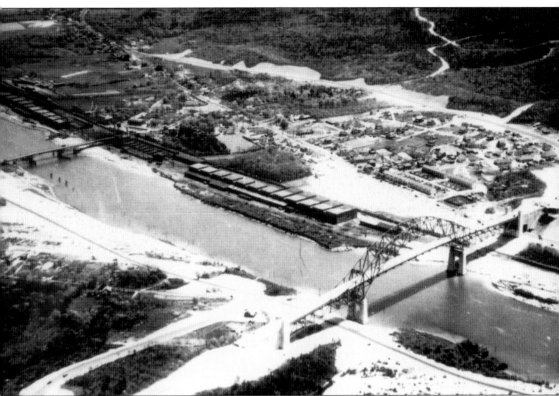

SAGAMORE FROM THE AIR, 1934. Although the Keith Car and Manufacturing Company was closed in 1928, most of the property remains unchanged in this 1934 aerial view. The new Sagamore highway bridge appears to be complete, but connecting roadways are not. The bridge was not opened until a year after the photograph was taken. The rows of apartment houses near the foot of the bridge were constructed by Keith to house the plant's immigrant workers and still stand today. (Courtesy of Howard Goodwin.)

Cape Cod Rail Road!

EXCURSION
TO
BOSTON.

A splendid chance on

SATURDAY, AUGUST 16, 1851,
TO SEE
Brewer's Splendid Panorama!
OF THE
Mammoth Cave of Kentucky, Niagara Falls, and Western Prairies, &c. &c, now Exhibiting at
☞BOYLSTON HALL!☜

An extra Train will leave Sandwich at 7 A. M., stopping for Passengers at all the stations on the Cape Cod Road. Exhibition for the party as soon as they arrive in the City.

FARE to Boston and back, including admission to the Panorama, from each Station in Sandwich, 90 cents. From Agawam and all Stations above 90 cents.

RETURNING TRAIN LEAVES BOSTON AT 5 30 P. M.

Of the merits of the above Panorama it is not necessary to speak, suffice it to say that the Artists of Boston pronounce it the best ever exhibited in the city. No one should miss the present opportunity of going to Boston and seeing it.

Vocal and Instrumental Music at the exhibition.

S. BOURNE, Superintendent of Cape Cod Branch Rail Road.

"Times" Steam Cylinder Job Press—J. H. & F. F. Farwell, Printers, Nos. 3 and 5 State Street, Boston.

AN EXCURSION TO BOSTON, 1851. This early Cape Cod Railroad poster advertises an excursion to Boston to view a special art exhibition. By 1851, the railroad had connected Sandwich with Boston for about three years. (Courtesy of the Sandwich Archives.)

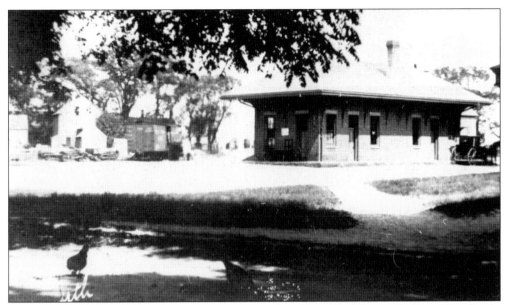

THE SANDWICH STATION. The station is shown from tree-lined Jarves Street in Sandwich, complete with a couple of chickens in the road. Note the boxcar being unloaded on the track that once served the Boston and Sandwich Glass Company across from the station. (Courtesy of Howard Goodwin.)

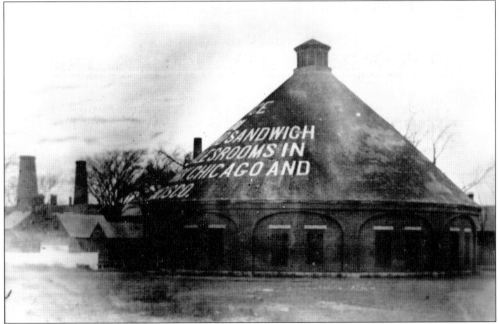

THE SANDWICH ROUNDHOUSE. This view of the Sandwich roundhouse dates from sometime after it was sold to the Boston and Sandwich Glass Company, which is advertising its wares on the roof. The roundhouse was originally constructed in 1848 upon the arrival of the railroad. With extension of the line from Sandwich to Hyannis in 1854, the roundhouse was no longer required by the railroad, and it was sold to the glass company. The company used it for storage and for packing and shipping. (Courtesy of the Sandwich Archives.)

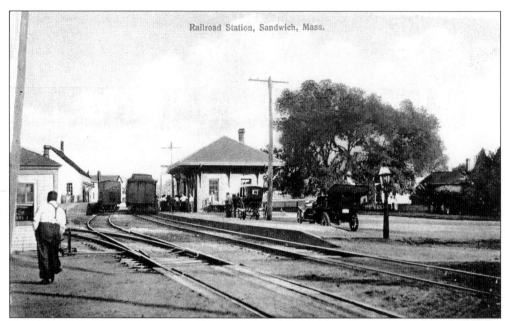

THE SANDWICH STATION. The freight house is visible to the left behind the crossing tender's shanty in this postcard view. (Courtesy of the Sandwich Archives.)

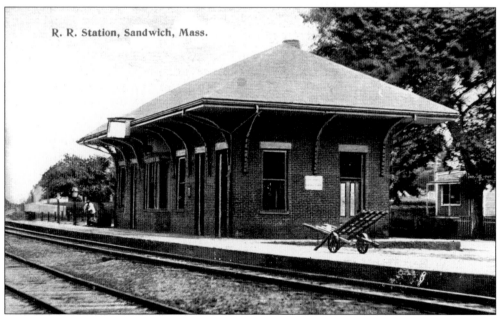

THE SANDWICH STATION. This structure was constructed in 1878 to replace the original built in 1848. It was damaged by fire in the 1970s and was later demolished. (Courtesy of the Sandwich Archives.)

CAPE COD B. RAIL ROAD
SALOON.

IN THE SANDWICH RAIL ROAD DEPOT.

REFRESHMENTS AND FRUITS
FOR THE ACCOMMODATION OF TRAVELLERS, TRANSIENT
VISITERS, AND CITIZENS OF THE TOWN.

THE SUBSCRIBER would take this method to inform his friends and the public, that he has taken this Stand, with the design to bestow unwearied pains in rendering it a place worthy of liberal patronage; and is ready AT ALL TIMES to give entertainments to such as may favor him with a call.

Passengers going to or from the Cape in the Cars, will find this a very convenient place to regale themselves, as the Coaches arrive in season to give them opportunity to breakfast before the start of the A. M. Train; and to dine before the start of the P. M. Train. Also, on return of A. M. and P. M. Trains, will find opportunity to get Refreshments, before taking the Coaches for the Cape.

Transient visiters and Parties of Pleasure will receive prompt attention; and will here find Luxuries usually afforded at similar Retreats.

On special occasions, SPECIAL efforts will be made to suit and accommodate his visiters, if previous notice be given.

The patronage of Gentlemen and Ladies is very respectfully solicited.

N. B. Doors open till the arr

THE SANDWICH STATION SALOON. This poster advertises a saloon at the railroad station in Sandwich. (Courtesy of the Sandwich Archives.)

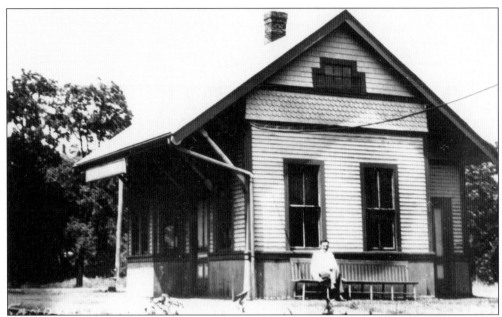

THE EAST SANDWICH STATION, 1930. Constructed in 1889, this was the second station to serve East Sandwich. The first one was moved down the tracks a bit to serve as the East Sandwich freight house. When the New Haven Railroad closed this station, a former railroad employee purchased it and moved it across the tracks, where it stands today as a private residence. While it has had several additions and renovations over the years, the distinctive eight-pane window is still visible from Route 6A. (Courtesy of Howard Goodwin.)

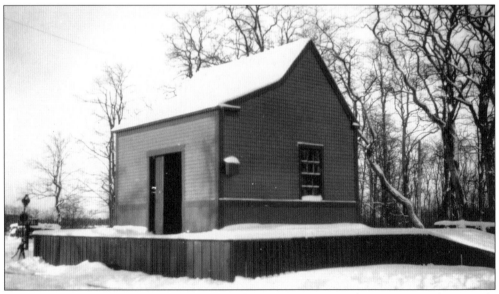

THE EAST SANDWICH FREIGHT HOUSE, JANUARY 31, 1931. In this view, note the "Royal" sign to the left, behind the switchstand. It was the station name that replaced "East Sandwich" due to the New Haven Railroad's concern for potential confusion from directional prefixes such as "East" on train orders. While the station survives today, the freight house does not. (Courtesy of Howard Goodwin.)

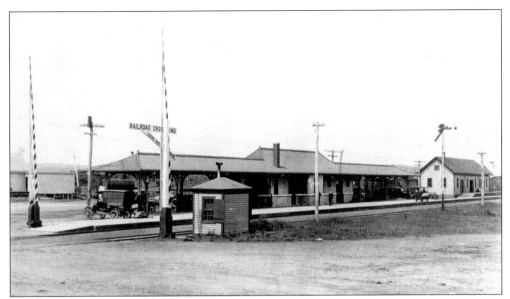

THE WEST BARNSTABLE STATION. This postcard view of the West Barnstable station, from the Meetinghouse Way (Route 149) grade crossing, probably dates from the 1920s. The small hip-roof shanty was for the crossing tender in charge of raising and lowering the crossing gates. Activity around the station suggests the imminent arrival of a train. The freight house is also visible farther down the platform. In the 1930s, the New Haven Railroad changed the name here to "Clement" in order to avoid confusion with the Barnstable station on train orders. (Courtesy of Philip H. Choate.)

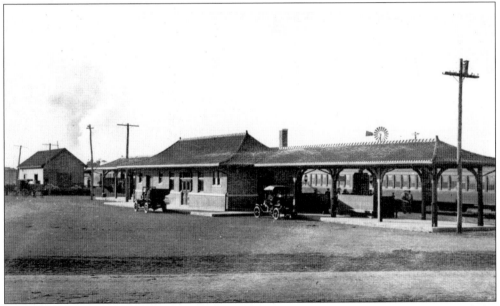

THE NEWLY BUILT WEST BARNSTABLE STATION, C. 1911. The smoke rising behind the freight house is from a steam locomotive about to leave West Barnstable for East Sandwich. The windmill visible on the other side of the tracks was not railroad related. Although the freight house and platform canopies are now gone, the station is currently undergoing restoration. (Courtesy of Howard Goodwin.)

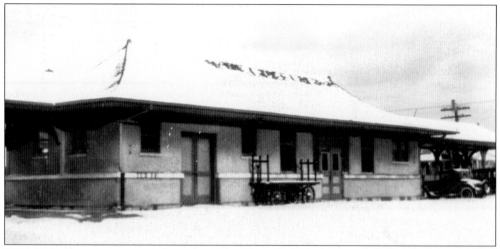

WEST BARNSTABLE STATION, JANUARY 31, 1931. The West Barnstable station, pictured after a snowfall, was constructed in 1911 and was used by the New Haven Railroad until the end of passenger service in 1964. Through the 1980s and mid-1990s, it served as a stop for the Cape Cod and Hyannis Railroad, as well as Amtrak's summer service to the Cape. This station is now owned by the Town of Barnstable. The Cape Cod Chapter of the National Railway Historical Society began leasing the station in 2001 for restoration. (Courtesy of Howard Goodwin.)

THE WEST BARNSTABLE FREIGHT HOUSE, JANUARY 1931. With fresh snow on the ground, here is the freight house at West Barnstable. (Courtesy of Howard Goodwin.)

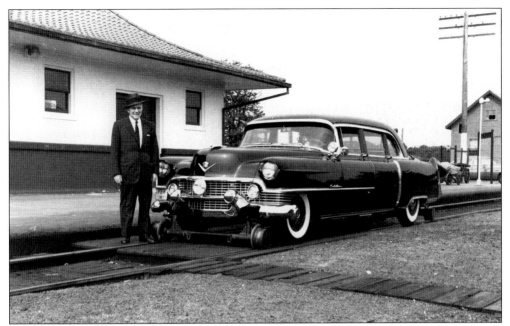

PATRICK B. MCGINNIS AT WEST BARNSTABLE. Patrick B. McGinnis was in charge of the New Haven Railroad between 1954 and 1956. Here, he makes an appearance at West Barnstable, traveling in style in his high-rail Cadillac. (New Haven Railroad photograph by Charles Gunn, courtesy of William Reidy.)

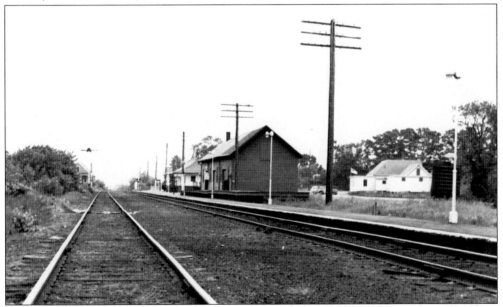

THE WEST BARNSTABLE STATION AND FREIGHT HOUSE, JUNE 9, 1955. This photograph looks "railroad south" (toward Hyannis) at West Barnstable from the siding, with the main track to the right. A boxcar sits behind the freight house to the far right. Today, the baggage car and caboose of the Cape Cod Model Railroad Club occupy this track, along with the caboose of the Cape Cod Stencil Company. (New Haven Railroad photograph by Charles Gunn, courtesy of William Reidy.)

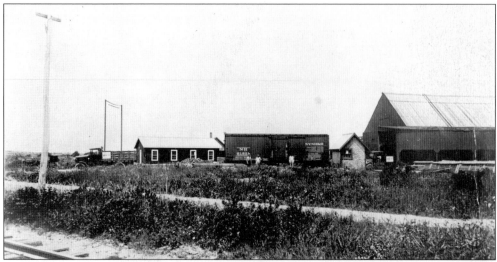

THE WEST BARNSTABLE BRICK COMPANY. The West Barnstable Brick Company was located on the edge of the great salt marsh in West Barnstable. The company was active from 1860 to 1927, with peak production of 100,000 bricks a day. In the photograph above, a boxcar can be seen on the spur leading into the property. Remnants of the brick company are barely visible now through the trees and brush. (Above, courtesy of the Barnstable Patriot; below, courtesy of Howard Goodwin.)

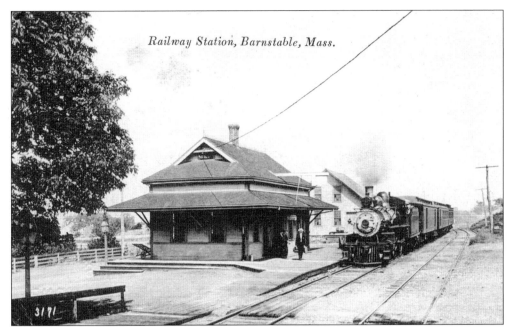

Railway Station, Barnstable, Mass.

THE BARNSTABLE STATION. This station at the end of Railroad Avenue in Barnstable Village was constructed in 1889 by the Old Colony Railroad. The Cape Cod Railroad originally reached this location in 1854 on its way to Hyannis. (Courtesy of the Sandwich Archives.)

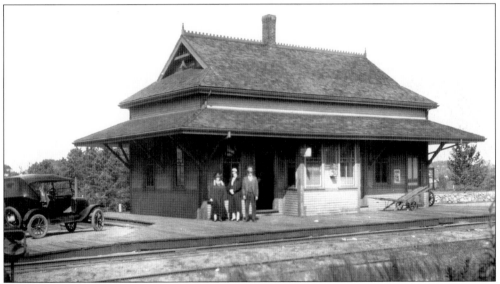

THE BARNSTABLE STATION, 1926. The first passenger train of the Cape Cod Railroad arrived in Barnstable Village on May 8, 1854, and this served as the endpoint for about a week and a half until the line was extended to Yarmouth Port. The station pictured here was constructed by the Old Colony Railroad in 1889. This photograph, along with many others found in this book, was taken by Louis H. Benton, an early railfan-photographer. In many of his earlier photographs, a bicycle is visible leaning against the station, suggesting that he traveled by bicycle from his home in Taunton to take the photographs. Its absence in his later photographs, such as this one, suggests that he eventually acquired an automobile. (Courtesy of Howard Goodwin.)

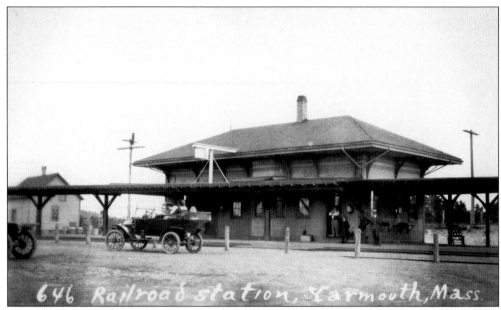

THE YARMOUTH STATION, 1914. The station pictured here is the second of three stations at Yarmouth; the first was built in 1854, when the line was extended to Hyannis. That station burned in 1878 and was replaced by this one, which was in service until it was destroyed by fire in 1941. (Photograph by Louis H. Benton, courtesy of Howard Goodwin.)

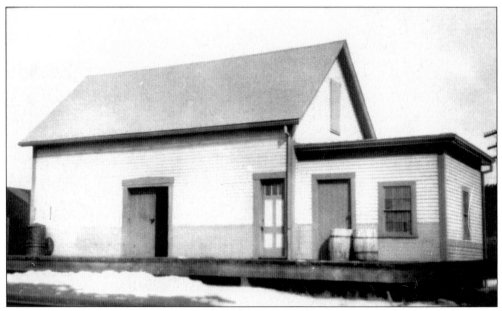

YARMOUTH, FEBRUARY 12, 1931. This photograph offers a view of the freight house at Yarmouth. (Courtesy of Howard Goodwin.)

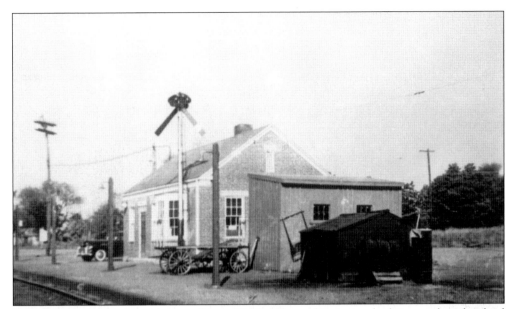

THE YARMOUTH STATION, C. THE LATE 1940S. Pictured in a view looking north is the third and final Yarmouth station to be built at the junction of the Cape main line and the Hyannis branch. (Courtesy of Howard Goodwin.)

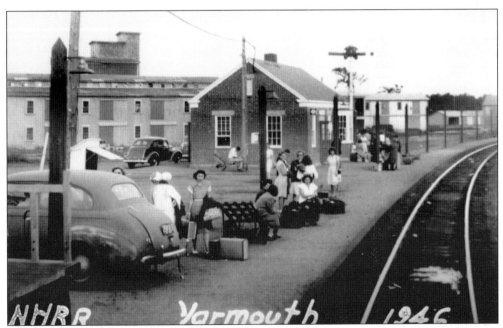

THE FINAL YARMOUTH STATION, 1946. This photograph appears to have been taken from the cab of a locomotive, probably an Alco DL-109 headed for Hyannis, with the waiting crowd watching from below. (Courtesy of Howard Goodwin.)

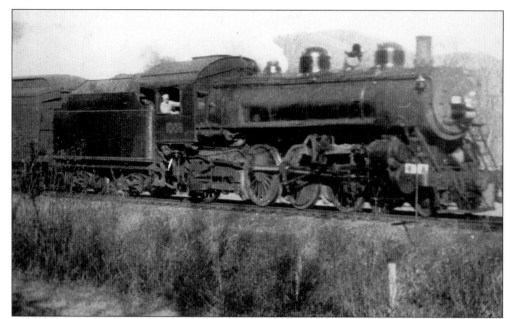

APPROACHING YARMOUTH. Another train approaches the Yarmouth station, this one led by I-1 Pacific-type locomotive No. 1008. Prior to the introduction of diesel locomotives, this would have been a very common sight on the Cape. (Courtesy of Howard Goodwin.)

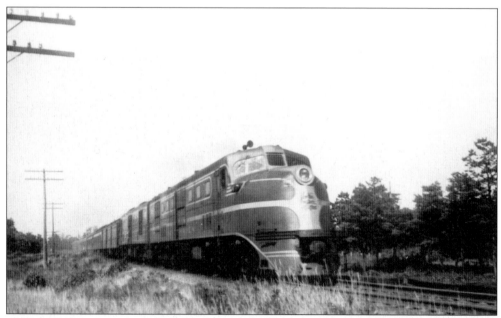

A NEW HAVEN TRAIN AT YARMOUTH, 1945. Two Alco DL-109 locomotives, each with a different New Haven paint scheme, lead a good-size train as it nears the Yarmouth station. This type of diesel locomotive was very common on the Cape in the 1940s and 1950s. (Courtesy of Howard Goodwin.)

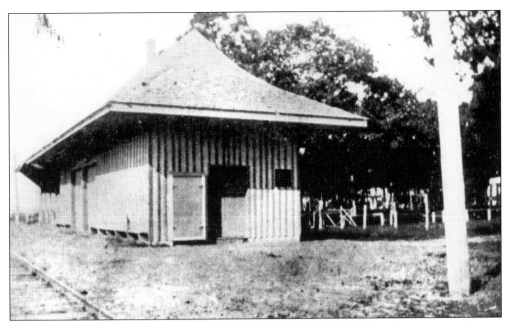

THE CAMP STATION, YARMOUTH. The Cape Cod Railroad constructed this station at the site of the Methodist campground in Yarmouth in 1863. By 1870, the railroad had also constructed a long siding here, as well as a long platform. Although the station itself was small, for a few weeks every year, thousands of passengers traveled to this location for summer camp meetings. The station remained here until 1925, when the New Haven Railroad sold it to an individual who moved it away. The last camp meetings were held in 1939; however, many of the cottages remain, and the railroad still passes by. (Courtesy of Howard Goodwin.)

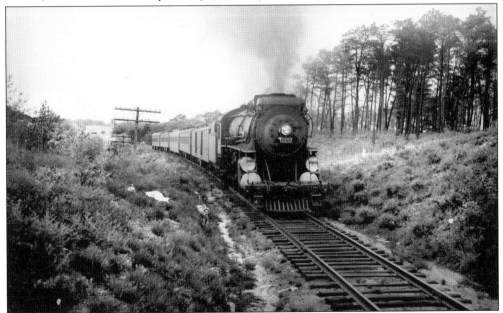

CAMP YARMOUTH DAY, JULY 2, 1939. New Haven Railroad No. 1372, an Alco I-4 Pacific-class locomotive, is seen hauling a train to the Yarmouth campground for Camp Yarmouth Day. (Courtesy of Howard Goodwin.)

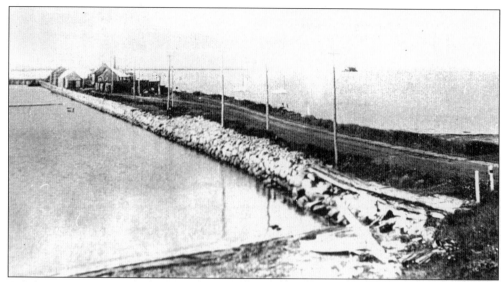

THE RAILROAD WHARF AT HYANNIS PORT, 1900. The Cape Cod Railroad constructed this 1,000-foot wharf into Nantucket Sound in 1854. The wharf served to connect the passenger ferries from Nantucket and Martha's Vineyard with the railroad until 1872, when the Woods Hole branch opened and the ferries went there instead. However, this wharf continued to serve other shipping until 1931. The 1.2-mile rail line between the wharf and downtown Hyannis was formally abandoned by the New Haven in 1937, and Old Colony Boulevard now occupies most of the right-of-way. (Courtesy of Howard Goodwin.)

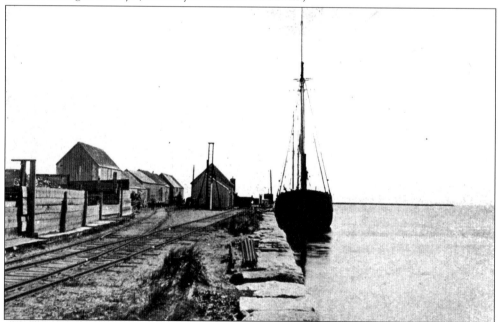

THE RAILROAD WHARF AT HYANNIS PORT. This photograph was taken near the end of the 1,000-foot railroad wharf at Hyannis Port. The wharf, which was originally used to meet the ferryboats from Nantucket and Martha's Vineyard, was later used to transfer freight between ship and rail. The line between here and the station on Main Street, a distance of about one and a quarter miles, was abandoned in 1937. (Courtesy of the Barnstable Patriot.)

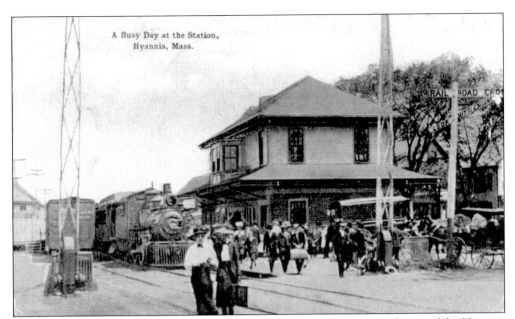

A Busy Day at the Station,
Hyannis, Mass.

'A BUSY DAY AT THE STATION,' C. 1914. The title sums up this postcard view of the Hyannis station. (Author's collection.)

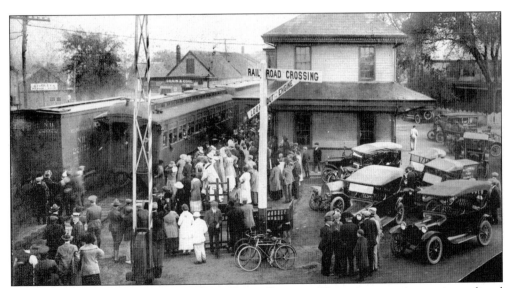

OFF TO WORLD WAR I. This view shows Depot Square in Hyannis as a train carrying enlisted men off to war is about to leave the station. (Courtesy of the Barnstable Patriot.)

43

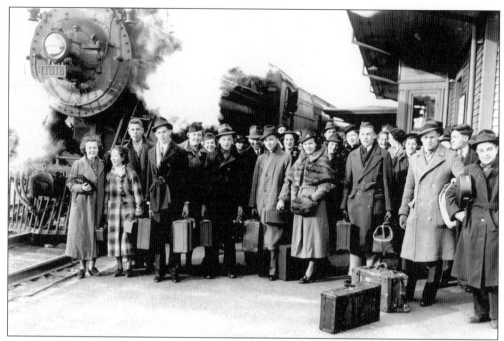

MUSICIANS AT HYANNIS, MARCH 1937. A group of high-school musicians has just gotten off the train in Hyannis en route to the New England Music Festival at Barnstable High School. (Courtesy of the Barnstable Patriot.)

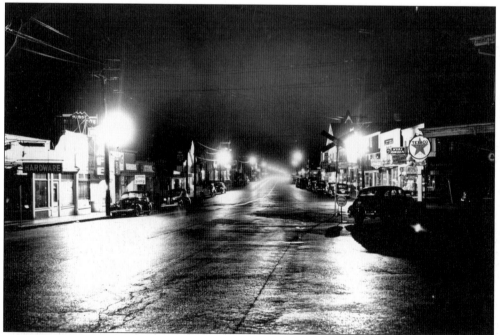

MAIN STREET IN THE RAIN, 1937. A rainy night at Depot Square is shown in a view looking west on Main Street in Hyannis. The tracks heading toward the railroad wharf are still across Main Street in this view, but they were abandoned by year's end. (Courtesy of the Barnstable Patriot.)

THE HYANNIS FREIGHT HOUSE, FEBRUARY 12, 1931. Hyannis was long a busy location for the railroad, not only with its own maintenance facilities but also with several freight customers around the yard, as well as a large freight house and one of the busier passenger stations on the Cape. (Courtesy of Howard Goodwin.)

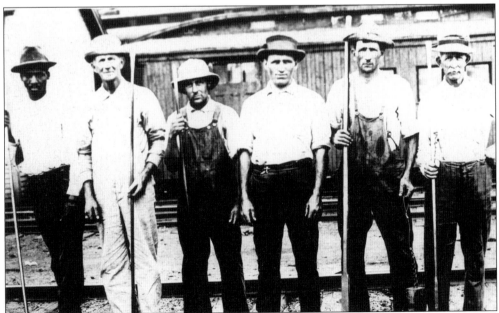

A TRACK GANG AT HYANNIS, 1914. Pictured, from left to right, are Pete Bapthiss, F. Walker, E. Baker, D. Cashman (noted as the boss, probably explaining why he is the only one without a lining bar), Jim Gifford, and Ben Walker. (Courtesy of Howard Goodwin.)

45

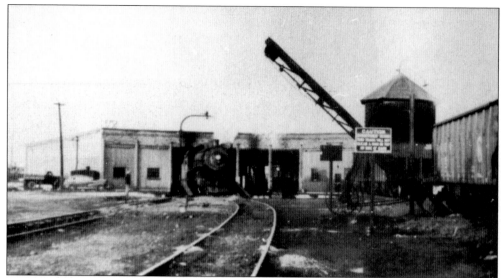

THE HYANNIS ROUNDHOUSE COMPLEX, C. THE 1940S. The roundhouse and turntable, pictured with a steam locomotive, are located in the Hyannis rail yard. This roundhouse is the only one left in southeastern Massachusetts and one of perhaps a half-dozen remaining in the state. The turntable has been removed, but the pit still remains. The water tower and coal trestle (not visible in this photograph) are also gone. The photographer stood near the site of the present Cape Cod Central Railroad enginehouse. (Courtesy of Howard Goodwin.)

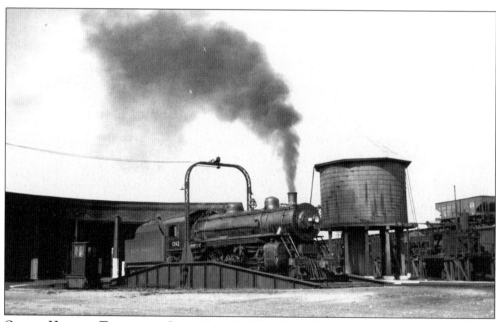

ON THE HYANNIS TURNTABLE, JUNE 13, 1947. New Haven locomotive No. 1342, an I-2 Pacific type, is on the turntable at the Hyannis yard. To the left is the roundhouse. Also visible is the water tank and part of the coal trestle, complete with a coal car. (Courtesy of Howard Goodwin.)

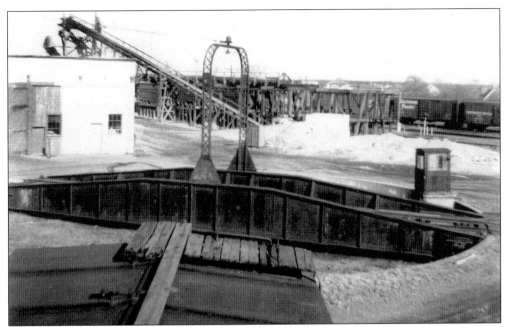

THE TURNTABLE AT HYANNIS. The turntable at the Hyannis yard is viewed here from atop an adjacent boxcar. The turntable is now gone, but the roundhouse remains, now housing a nightclub. (Courtesy of Robert Thompson.)

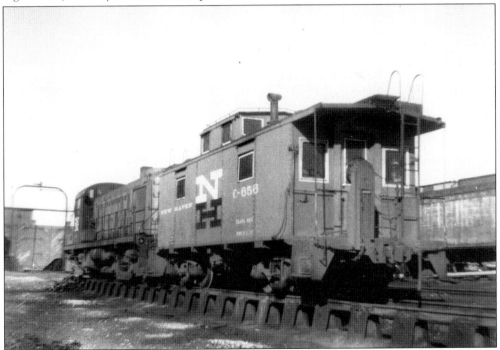

A CABOOSE AT HYANNIS, THE EARLY 1960S. An Alco RS-3 and caboose No. C-656 sit together on the ash pit in front of the roundhouse at Hyannis. Locomotives and cabooses like these were frequently to be found stationed at Hyannis in the 1960s. (Courtesy of Robert Thompson.)

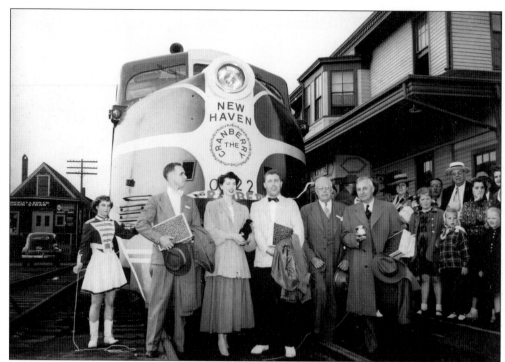

THE CRANBERRY AT HYANNIS. Judging from the well-dressed crowd gathered around Alco DL-109 No. 0722, this photograph is likely from the 1949 inaugural run of the New Haven's train called the *Cranberry*. This was a very popular run between Boston and Hyannis. This particular Alco locomotive was painted into a special cranberry-colored paint scheme. Three gentlemen posing in front of the train are holding boxes of cranberries, with the man to the right clutching a can of cranberry sauce. (Courtesy of the Barnstable Patriot.)

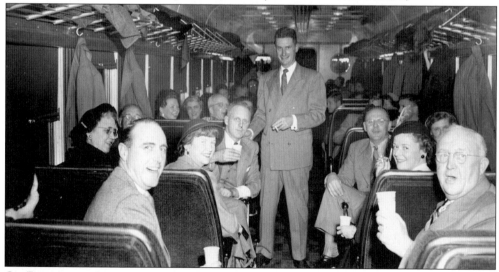

ON BOARD THE CRANBERRY. This photograph was taken on board the New Haven's Boston-to-Hyannis train, the *Cranberry*, possibly on one of its first runs. Norman H. Cook, executive secretary of the Cape Cod Chamber of Commerce, is standing in the center. Surely, there is cranberry juice in those cups everyone is holding. (Courtesy of the Barnstable Patriot.)

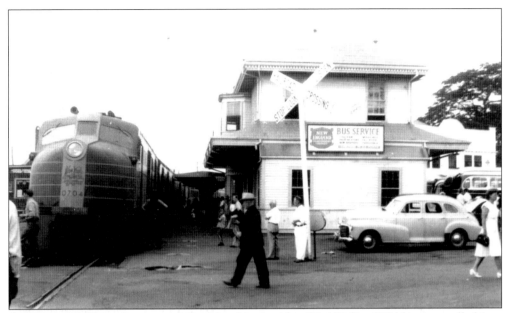

ARRIVING AT HYANNIS, THE 1940S. New Haven Alco DL-109 No. 0704 has just pulled into the Hyannis station. Note the sign on the station advertising the New Haven's bus service (New England Transportation Company), while there is no visible mention of rail service of any kind. Also note the white building partially visible on the right side behind the station. This building now houses the Cape Cod Central Railroad station and offices. (Courtesy of Howard Goodwin.)

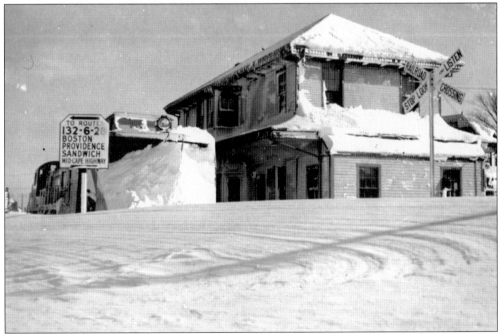

A SNOW PLOW AT THE HYANNIS STATION, THE EARLY 1950S. A New Haven Railroad Alco Road-Switcher with snow plow arrives at the Main Street station in Hyannis. (Courtesy of Allen F. Speight.)

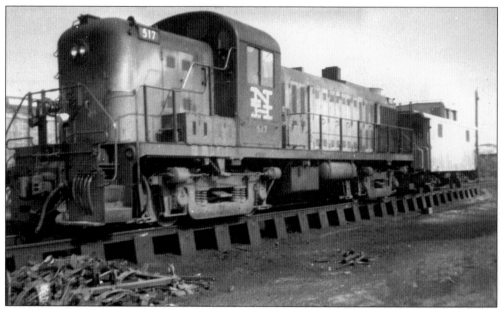

A NEW HAVEN RS-3 AND CABOOSE IN HYANNIS. Alco RS-3 No. 517, shown here with a caboose sitting on the ash pit in front of the Hyannis roundhouse, was the first unit of the New Haven Railroad's initial purchase of these locomotives in 1950. By 1952, the New Haven had acquired 45 of these units. The RS-3 became the most versatile of all the New Haven's Alco motive power and was well-liked by crews. (Courtesy of Allen F. Speight.)

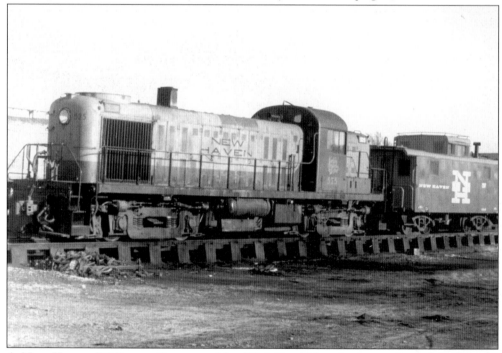

A NEW HAVEN RS-3 AND CABOOSE. Alco RS-3 No. 525 and caboose sit on the ash pit in front of the roundhouse at the Hyannis yard, at the present site of the Cape Cod Central Railroad enginehouse. (Courtesy of William Reidy.)

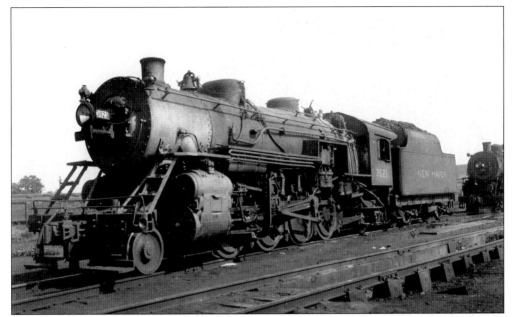

A J-1 LOCOMOTIVE RESTING AT HYANNIS, 1947. New Haven Railroad No. 3023, a J-1-class locomotive built by Alco in 1916, is resting between runs at the Hyannis yard. This type of locomotive was very common on Provincetown freight trains. Within five years, all steam locomotives were gone, as the New Haven completely dieselized in the winter of 1952. (Courtesy of William Reidy.)

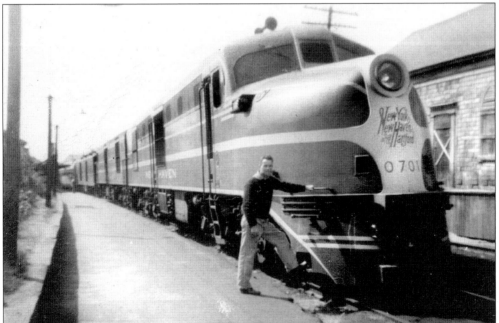

A NEW HAVEN DL-109 WAITING TO DEPART HYANNIS, C. THE 1940S. In December 1941, Alco DL-109 No. 0701 and its sister, No. 0700, were the first two of this model to arrive on the New Haven Railroad. These units, commonly used in both freight and passenger service, were the first dual-service fleet for the New Haven. (Courtesy of Allen F. Speight.)

CAPE COD RAIL ROAD.

PRICES OF
SEASON TICKETS,

TO TAKE EFFECT MAY 1, 1860.

From BOSTON to	1 yr.	6 ms.	3 ms.
Hyannis	$145	$80	$45
Yarmouth.....	145	80	45
Barnstable	143	79	44½
W. Barnstable .	140	77	44
Sandwich	140	77	44
W. Sandwich..	137	75	43½
N. Sandwich ..	137	75	43½
Monument	137	75	43½
Agawam	135	74	43
Wareham	135	74	43
S. Wareham...	132	73	42½
Tremont	132	73	42½
S. Middleboro':	130	72	42
Rock	130	72	42

Tickets may be procured at the Superintendent's office, in Hyannis.

To → From ↓	Hyannis.	Yarmouth.	Barnstable.	W. Barnstable.	Sandwich.	W. Sandwich.	N. Sandwich.	Monument.	Cohasset.	Agawam.	Wareham.	S. Wareham.	T. I. Works.	S. Middleboro'	R. M. House.	Middleboro'.
Hyannis,		8	10	13	18	20	22	24	25	27	29	31	32	35	37	40
Yarmouth,			7	10	16	18	19	21	22	24	26	28	29	32	34	38
Barnstable,				8	14	16	17	19	20	22	24	26	28	30	32	36
W. Barnstable					13	15	16	18	19	22	23	25	27	29	31	35
Sandwich,						7	8	10	11	13	15	18	19	22	24	28
W. Sandwich,							6	8	9	12	13	16	17	20	22	26
N. Sandwich,								7	8	11	12	14	16	18	20	24
Monument,									6	8	10	12	14	16	18	22
Cohasset,										7	9	12	13	15	17	21
Agawam,											7	9	10	13	15	19
Wareham,												7	8	11	13	17
S. Wareham,													6	9	11	15
T. I. Works,														8	10	14
S. Middleboro'															7	12
R. M. House,																11
Middleboro', (SCHOLARS' TICKETS)	16	16	15	14½	13	12½	12	11½	11	10½	10	9½	9	8½	8	

LOCAL TICKETS, For Three Months. A proportionate discount from quarterly rates, as in case from " Boston to Hyannis," will be made on local season tickets for over three months.

Scholars and children under 15 years of age, half price; between 15 and 18 years, three quarters of above prices—except Scholars' Tickets to Middleboro'.

SEASON TICKETS are sold subject to the following rules and conditions, which form part of the contract of sale.

1. *All tickets will be made to terminate at the expiration of a month.*

2. THEY MUST IN ALL CASES BE PREPAID.

3. For not exceeding ONE month, 50 per cent of quarterly rates. For over one and not exceeding Two months, 75 per cent of quarterly rates. For over two and less than THREE months, same as three.

4. Any person who shall have paid the quarterly rate for a ticket for two successive quarters, shall be entitled to a ticket for the two remaining quarters at 45 per cent of the yearly rate.

5. They will be issued for any length of time beyond the regular term, or will be extended (if requested before they expire) on the following terms : *Quarterly* Tickets at the rate of quarterlies. *Six-months* Tickets for three months or less in addition, at the rate of quarterlies ; for four months or over, at the rate of semi-annual. *Yearly* Tickets, for three months or less in addition, at the rate of quarterlies ; for four months or over, at the rate of semi-annual.

6. A Three Months Ticket may be exchanged for one of six or twelve months, within *sixty* days after it is issued, by paying the difference in price.

7. Persons passing over the road without a ticket, are liable to a penalty, and to the *full* fare. Nor will they in any case be issued to any persons who are or have been delinquents, or who have passed over the road without paying the fare due from them, except at the option of the Company.

8. No allowance made for non-usance, except on the surrender of the ticket, when the amount paid will be refunded, deducting one regular fare for every day it has been issued, until the amount shall equal the price of a three months ticket. And if the ticket has been issued longer than three months, then deducting the price that would have been charged had the ticket been originally taken for the time it has been held, adding in all cases to the end of the current month.

9. No transfer of Season Tickets will be permitted.

10. No person is entitled to pass over the road in the trains unless he has the ticket with him, and exhibits it to the conductor when requested to do so ; if he fails to do so, he will be charged with the regular fare, *which will not be refunded.*

11. Season Tickets are subject to the general regulations of the road, and do not entitle the holder to carry with him any thing *but his own personal baggage.*

☞ The Company is not bound to advise Season Ticket holders of the expiration of their tickets.

E. N. WINSLOW, Sup't.

A SEASON TICKET PRICE CHART, MAY 1, 1860. This poster lists season-ticket prices for the Cape Cod Railroad. (Courtesy of William Reidy.)

Two

YARMOUTH TO ORLEANS

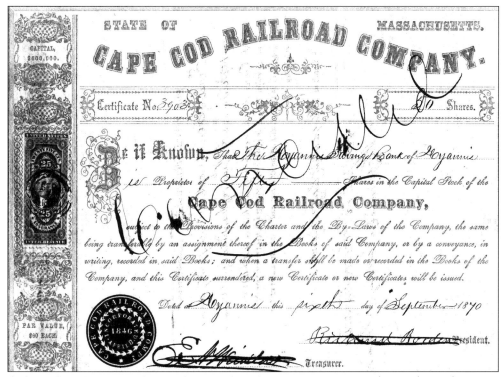

A CAPE COD RAILROAD STOCK CERTIFICATE, SEPTEMBER 6, 1870. This stock certificate was issued to the Hyannis Savings Bank for 50 shares of company stock. (Courtesy of William Reidy.)

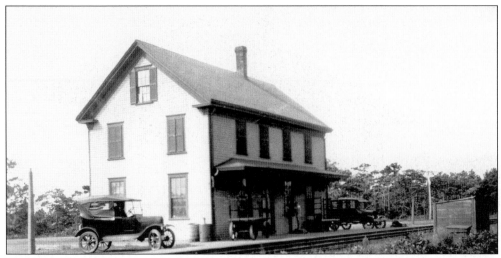

THE BASS RIVER STATION, 1926. This station, on Station Avenue, served South Yarmouth. It was originally constructed in 1865 about a mile east of here, off Great Western Road near Bass River. At that location, it was named North Yarmouth but then changed to East Yarmouth and finally to Yarmouth Farms. However, as South Yarmouth was developing more around the Station Avenue area, the New Haven decided to move this station in 1901. It was partially disassembled and placed on flatcars for the move. Once rebuilt in its new location, it was renamed South Yarmouth. Later, however, the New Haven renamed numerous stations to leave off directional identifiers (such as North or South). This station was almost called Mozart, but the New Haven ended up with Bass River, a name that stuck until the station was closed in 1936 and torn down a year later. (Photograph by Louis H. Benton, courtesy of Howard Goodwin.)

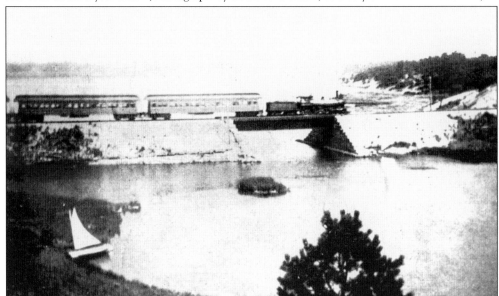

CROSSING BASS RIVER. The original bridge across Bass River, which separates Yarmouth and Dennis, was constructed of wood and built by the Cape Cod Central in 1865, when the line to Orleans was constructed. The steel span in this photograph replaced the original wooden one and still stands today, although its tracks have not seen a train for several years. (Courtesy of Howard Goodwin.)

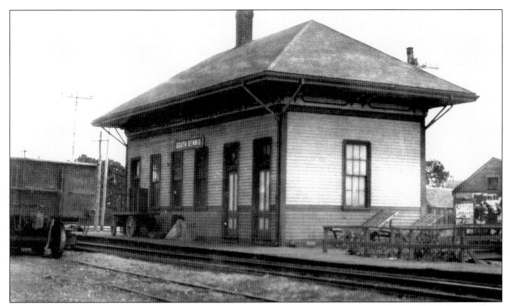

THE SOUTH DENNIS STATION, 1926. From this station, it was one and a half miles to Bass River (to the west) and North Harwich (to the east). This station dates from the 1880s, and its architecture resembles numerous other Cape Cod stations from that same period. However, the absence of a bay window is unique. South Dennis marks the end of the line for today's railroad, although the track heading east from Station Avenue in South Yarmouth has been out of service for several years now. (Photograph by Louis H. Benton, courtesy of Howard Goodwin.)

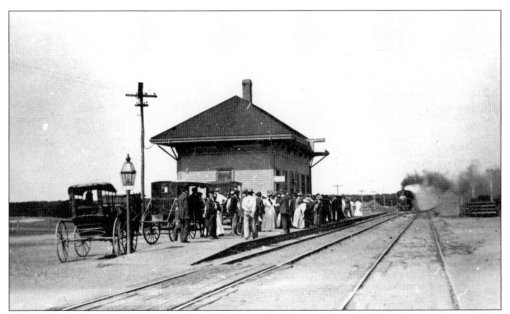

SOUTH DENNIS, AUGUST 5, 1910. A large crowd watches the arrival of the Provincetown-bound train—and for good reason. On that day, the Pilgrim Monument was to be dedicated with a grand celebration. (Courtesy of Howard Goodwin.)

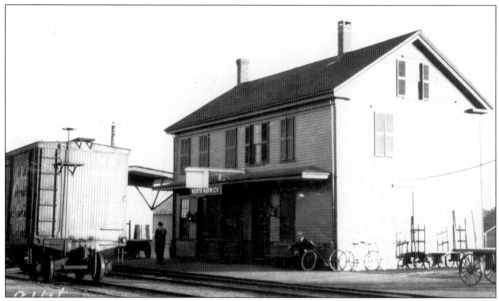

THE NORTH HARWICH STATION, 1916. One of those bicycles must belong to photographer Louis H. Benton, who took this photograph. In later years, the New Haven designated this station as "Norman." The station was located about one and a half miles from South Dennis and was the first of four stations in Harwich. (Courtesy of Howard Goodwin.)

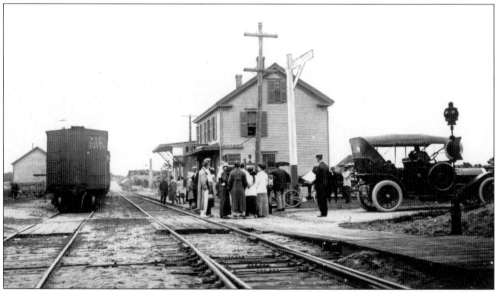

WAITING FOR THE TRAIN AT NORTH HARWICH. A fairly large crowd is waiting for the arrival of the next train, probably due in a matter of minutes. Ocean Spray once operated a large cranberry plant near this location in North Harwich and was one of the many wayside customers that the railroad served on the Cape. (Courtesy of Howard Goodwin.)

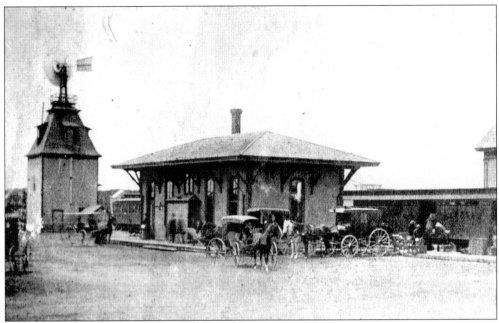

THE HARWICH STATION, 1887. With the completion of the Chatham branch in 1887, Harwich was home to four railroad stations, including this one at the junction of that branch. Of particular interest in this photograph is the square water tank adjacent to the station, with a windmill on top. The windmill operated a water pump to fill the water tank. (Courtesy of Howard Goodwin.)

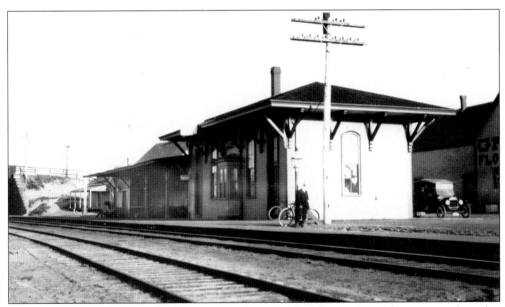

THE HARWICH STATION AND FREIGHT HOUSE, 1916. While it may not be apparent from this photograph, Harwich was a very busy junction for the railroad and included a turntable and wye track for turning trains, along with a water tower. This was one of the four stations located in Harwich. (Courtesy of Howard Goodwin.)

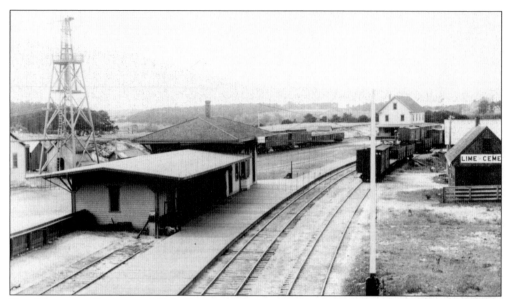

THE HARWICH STATION, 1898. Compare this view of Harwich with the previous one. While the station remains, a freight house has been constructed directly adjacent to it. A new windmill has been constructed, and the square water tank appears to be gone. This view is from the overhead bridge just west of the station complex. The white pole in the foreground is supporting a telltale. Harwich was home to both a turntable and a wye track (not visible here). (Courtesy of Howard Goodwin.)

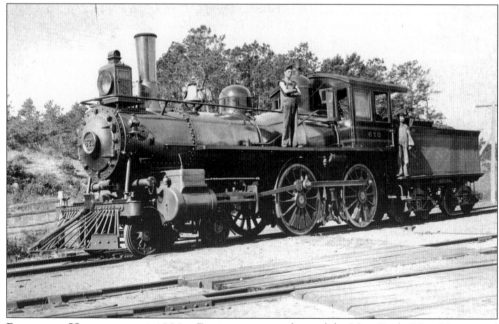

POSING AT HARWICH, THE 1890s. Engine crew members of the New York, New Haven and Hartford Railroad No. 670, a 4-4-0 American type (renumbered in 1904 to 2019) pose at Harwich while awaiting their next assignment. This locomotive was regularly assigned to service on the Chatham branch. (Courtesy of Howard Goodwin.)

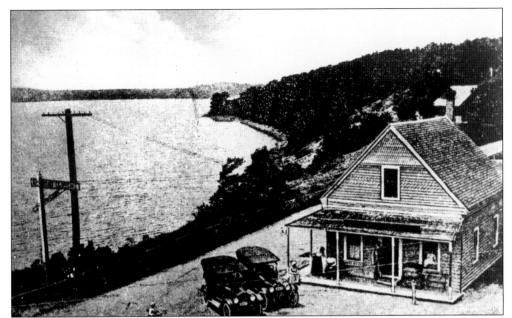

THE PLEASANT LAKE STATION, BREWSTER. Prior to the arrival of the railroad, this building existed as a general store. Once the train came to town, tickets were sold here, and a freight house was erected across the street. The general store still stands today, but the freight house is gone, replaced by a parking lot for the recreational bike path that now occupies the right-of-way. (Courtesy of Howard Goodwin.)

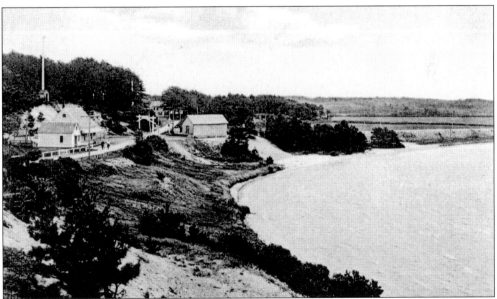

THE VILLAGE OF PLEASANT LAKE. The railroad station to the left, in the Harwich village of Pleasant Lake, was originally a general store and still exists today. The building across the road from the store (center) was the freight house, and today this site is used as a parking lot for the Cape Cod Rail Trail. The body of water on the right is Hinckley's Pond. (Courtesy of Howard Goodwin.)

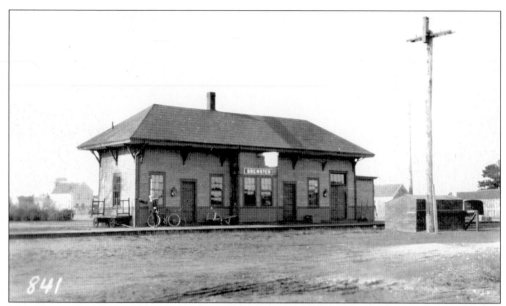

THE BREWSTER STATION, 1916. This station, with its hip roof, was a typical design often found on the Cape. It was located near Route 137 and Underpass Road in Brewster. While the station is no longer standing, the right-of-way is now used as a recreational bicycle path. (Courtesy of Howard Goodwin.)

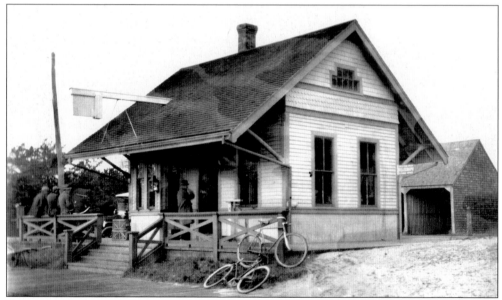

THE EAST BREWSTER STATION. This was one of three stations in Brewster. The railroad reached here in 1865, with the 19-mile extension from Yarmouth to Orleans. When the New Haven no longer needed the station, it was sold to an individual who moved it for use as a summer cottage. (Courtesy of Howard Goodwin.)

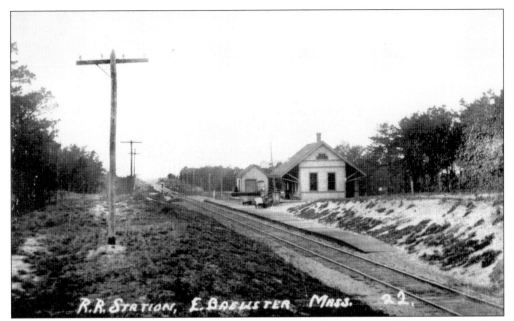

THE EAST BREWSTER STATION. Above is another view of the station and freight house at East Brewster. The photograph below shows the building in its new location, serving as a private summer cottage. (Above and below, courtesy of Howard Goodwin.)

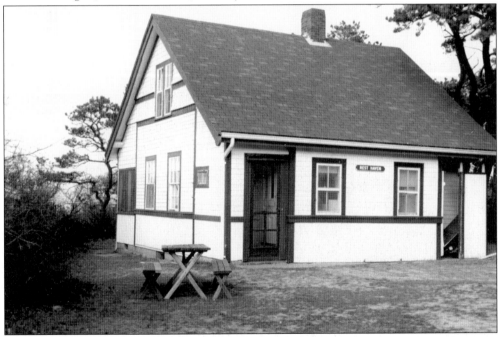

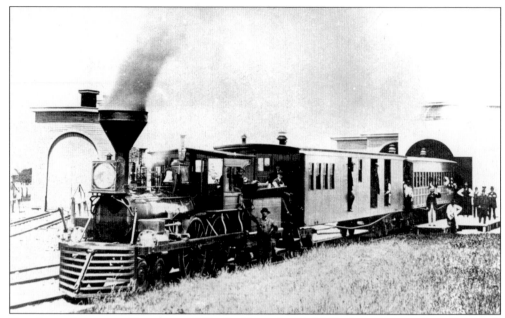

THE FIRST TRAIN TO ORLEANS, 1865. On December 6, 1865, the extension from Yarmouth to Orleans was officially opened. Cape Cod Railroad locomotive No. 4, named *Barnstable* (later to become Old Colony No. 48, *Nauset*), led this inaugural run. It is seen here upon its arrival at Orleans. This was the first station at Orleans and featured a trainshed to protect passengers from foul weather. To the left is the single-stall enginehouse, with a small turntable immediately in front of it. Orleans served as the terminus of the Cape Cod Railroad until the tracks were extended to Wellfleet by 1871 and to Provincetown by 1873. (Courtesy of Howard Goodwin.)

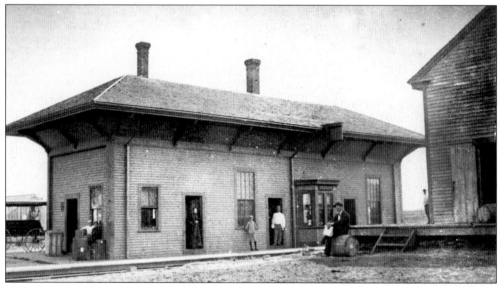

THE ORLEANS STATION, 1890. The station pictured here at Orleans was the second one constructed, replacing the original built in 1865. This view shows the passenger station and part of the freight house on the right, with the tracks running between the two. Regular passenger service ended here in the late 1930s. (Courtesy of Howard Goodwin.)

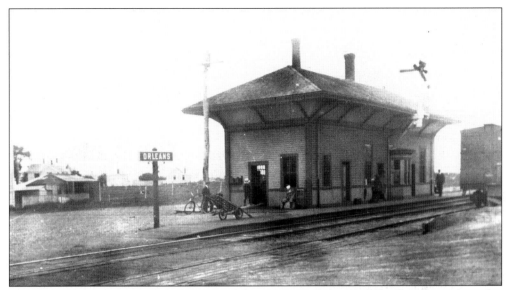

THE ORLEANS STATION. Here is a view of the station at Orleans, with a boxcar to the right, spotted next to the freight house (not visible). (Courtesy of Howard Goodwin.)

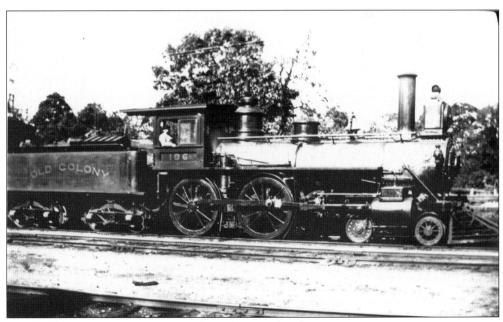

AN OLD COLONY LOCOMOTIVE. Old Colony Railroad No. 186, a 4-4-0 American type, is shown here on the siding at Orleans. (Courtesy of Howard Goodwin.)

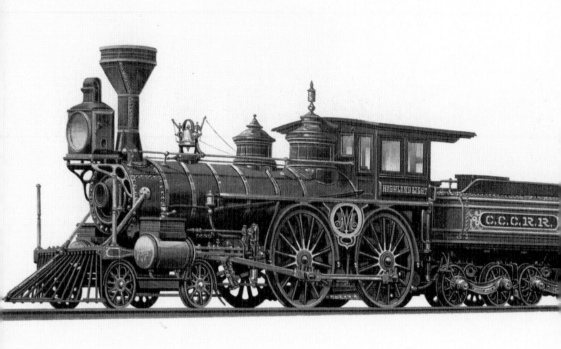

Cape Cod Central R.R. 1867

THE *HIGHLAND LIGHT*. The Cape Cod Central Railroad was created to construct a railroad between the towns of Yarmouth and Orleans. A group of stockholders of the Cape Cod Railroad (whose charter only allowed for running to Hyannis) formed the Cape Cod Central and applied for a charter from the legislature to construct the new line. The charter was approved and the company incorporated in 1861. Construction of this route began on July 4, 1864, and the first train traveled the 19 miles from Yarmouth Port to Orleans on December 6, 1865.

The locomotive *Highland Light* was built by the William Mason Machine Works of Taunton in 1867. Railroad historian and writer Lucius Beebe called it "the handsomest steam locomotive ever built in America." Many drawings of this locomotive (including this one) incorrectly identify it as belonging to the Cape Cod Central Railroad (the "C.C.C.R.R." on the tender). The Cape Cod Central was really only a railroad on paper and never owned any equipment of its own. All trains that ran on its tracks (between Yarmouth Port and Orleans) were Cape Cod Railroad trains, operated by Cape Cod Railroad crews. (Author's collection.)

Three

ORLEANS TO
PROVINCETOWN

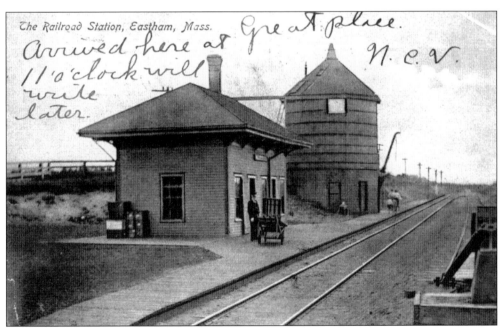

A POSTCARD VIEW OF EASTHAM. This station at Eastham was constructed in the 1880s and remained in service until 1940, when it was torn down. Eastham was unique in that it had two railroad water tanks, each fed from a different pond. The view is from a postcard cancelled in 1907. (Courtesy of Howard Goodwin.)

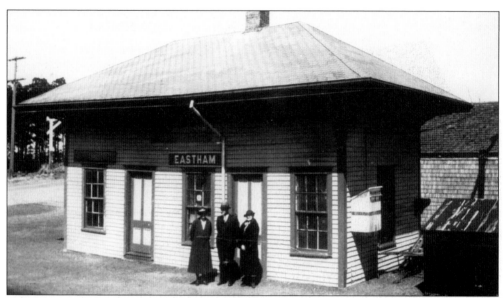

THE EASTHAM STATION, 1926. In this Louis H. Benton photograph of the Eastham station, a few people pose on the platform, including the photographer's wife (left). (Courtesy of Howard Goodwin.)

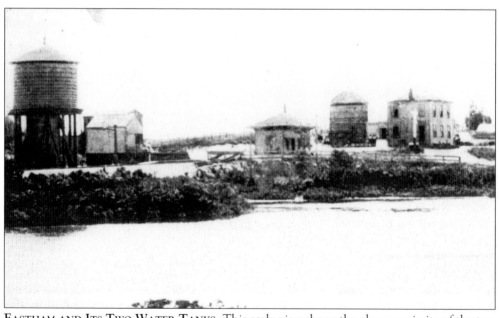

EASTHAM AND ITS TWO WATER TANKS. This early view shows the close proximity of the two water tanks to the Eastham station (near the center). (Courtesy of Howard Goodwin.)

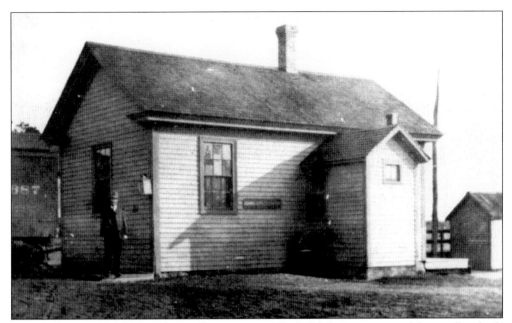

THE NORTH EASTHAM STATION. This station at North Eastham was one of the smallest built on the Cape. When the New Haven renamed stations with directional prefixes in the 1930s, this became Hastings. The station was closed in 1935. (Courtesy of Howard Goodwin.)

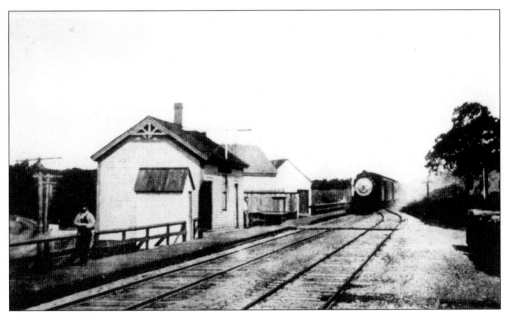

A TRAIN APPROACHING THE SOUTH WELLFLEET STATION. With the train pulling in, the station agent is waiting on the platform to help unload any baggage or express destined for South Wellfleet. (Courtesy of Howard Goodwin.)

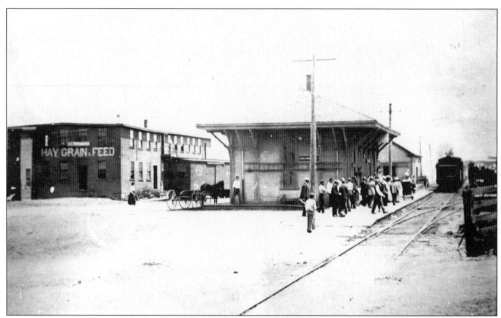

A BUSY DAY AT WELLFLEET. A good-sized crowd waits for the train on this day at Wellfleet. A.C. Freeman and Company (hay, grain, and feed supply) is visible behind the station, where the boxcar is being unloaded. (Courtesy of Howard Goodwin.)

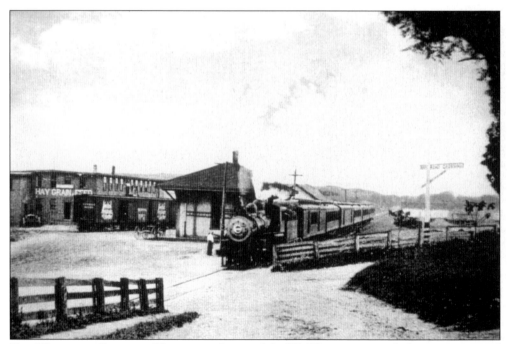

THE WELLFLEET STATION. This postcard view of the Wellfleet station includes a train stopped there. (Courtesy of Howard Goodwin.)

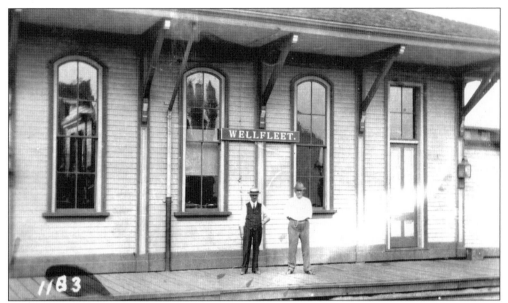

THE WELLFLEET STATION. The Cape Cod Railroad reached Wellfleet in 1870, and this was the end of the line until the 14-mile extension to Provincetown was complete by 1873. Passenger service continued into the 1930s, and the tracks were abandoned here in 1960. (Courtesy of Howard Goodwin.)

THE COMET AT WELLFLEET, 1935. The *Comet*, built by the Goodyear Zeppelin Company for the New Haven Railroad, was a three-car articulated train capable of reaching speeds of nearly 110 miles per hour. Of course, its speed on the Cape lines was far below that. This unique train was in service on the New Haven until the early 1950s. When it toured the Cape in May 1935, the *Comet* drew huge crowds, including 2,000 in Wareham and 2,400 in Falmouth. (Courtesy of Howard Goodwin.)

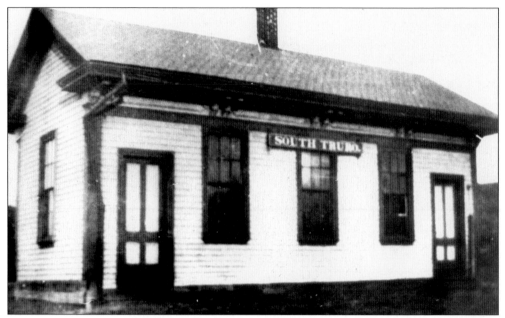

THE SOUTH TRURO STATION. The railroad reached South Truro in 1873, and passenger service continued into the 1930s. The tracks were abandoned between Provincetown and North Eastham in 1965. (Courtesy of Howard Goodwin.)

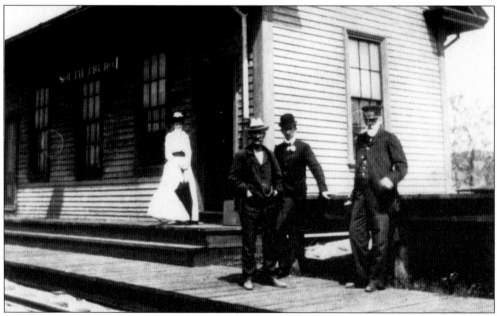

THE SOUTH TRURO STATION. In this undated view of the South Truro station, a group poses for the photographer. On the far right is the station agent. (Courtesy of Howard Goodwin.)

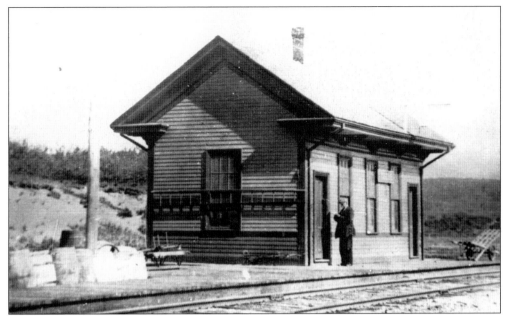

OPENING UP AT TRURO. The Truro station agent opens the station in preparation for the train's arrival. The ladder, typical to most stations, would have been used to gain access to the roof in case of fire. A barrel of water, along with buckets, could also be found nearby. (Courtesy of Howard Goodwin.)

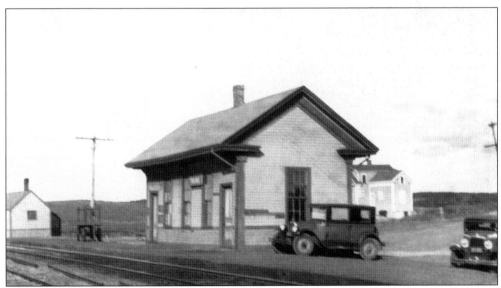

TRURO, 1932. This photograph shows the Truro station and freight house. (Photograph by Louis H. Benton, courtesy of Howard Goodwin.)

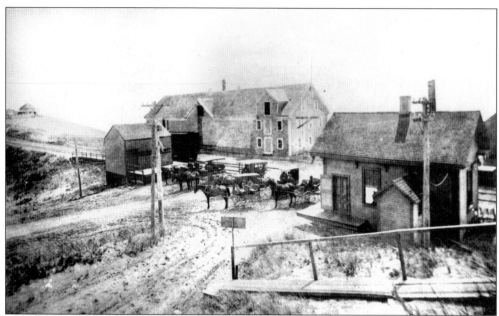

THE NORTH TRURO STATION, 1907. The train must be due in to North Truro very soon, as several horse-drawn carriages are awaiting its arrival. This area was home to industry in its day, including both fish freezing and canning plants, as well as a candle factory. This station was designated Moorland in later years. (Courtesy of Howard Goodwin.)

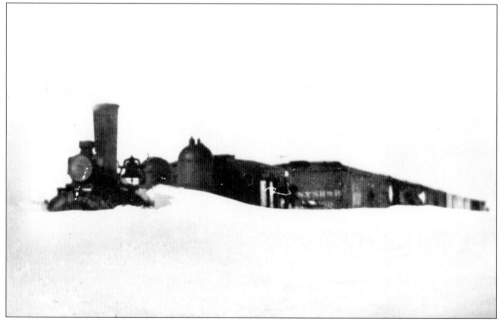

STUCK IN THE SNOW, EARLY JANUARY 1910. This unlucky train found a rather deep snowdrift in North Truro. As some of the snow was 15 feet deep, it took over three days to clear the line after the storm. The fireman on this trip, George A. McComisky, was able to keep the fire going in this locomotive for the entire time it was stuck, and he melted snow for the needed water. (Courtesy of Howard Goodwin.)

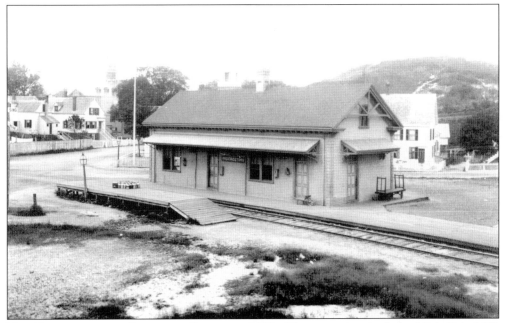

THE PROVINCETOWN RAILROAD STATION, 1888. This rare view includes High Pole Hill, directly behind the station, before construction of the Pilgrim Monument, which was completed in 1910. (Courtesy of Howard Goodwin.)

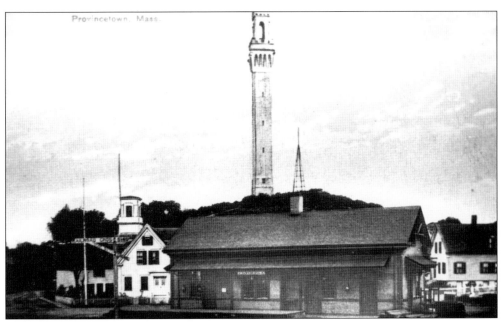

THE PROVINCETOWN STATION. The Pilgrim Monument is visible on High Pole Hill in this post-1910 view. The station was constructed in 1873 and remained into the 1930s, when passenger service to the tip of the Cape was discontinued. (Courtesy of Howard Goodwin.)

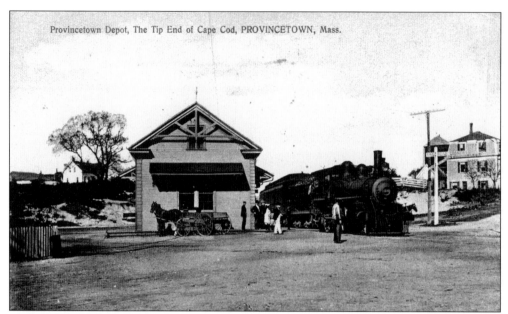

Provincetown Depot, The Tip End of Cape Cod, PROVINCETOWN, Mass.

A TRAIN AT THE STATION, PROVINCETOWN. Here is the passenger station at Provincetown, where a train has recently arrived in this undated postcard view. It was 120 miles between here and Boston by rail. Provincetown was also home to both a turntable and wye track, as well as a water tank, coal dock, and railroad wharf. (Courtesy of Howard Goodwin.)

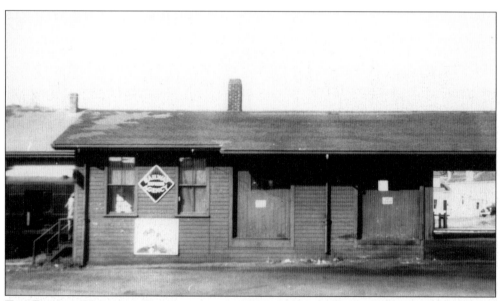

THE FREIGHT HOUSE AT PROVINCETOWN, 1948. Although the freight house was still at its original location when this photograph was taken, its days were numbered. Within the next few years, the New Haven placed a caboose here to serve as the freight agent's office. (Courtesy of Howard Goodwin.)

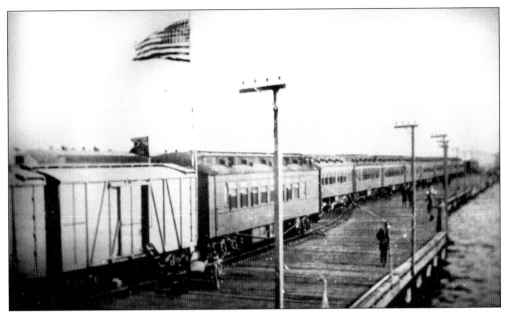

THE PROVINCETOWN RAILROAD WHARF, AUGUST 5, 1910. At this wharf, passengers and freight could transfer between boat and the national rail network. The occasion requiring so many passenger cars was the dedication of the nearby Pilgrim Monument. Along with thousands of spectators, plenty of dignitaries were on hand, including Gov. Eben Draper and Pres. William H. Taft. Although the dignitaries may have traveled to the ceremony by ship, most of the spectators traveled to the event by train. (Courtesy of Howard Goodwin.)

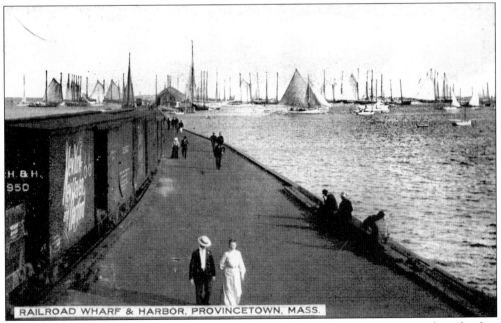

THE PROVINCETOWN RAILROAD WHARF. A few freight cars are sitting on the wharf at Provincetown in this postcard view. Note the abundance of sailboats in the harbor. Both freight and passenger trains used this wharf. (Author's collection.)

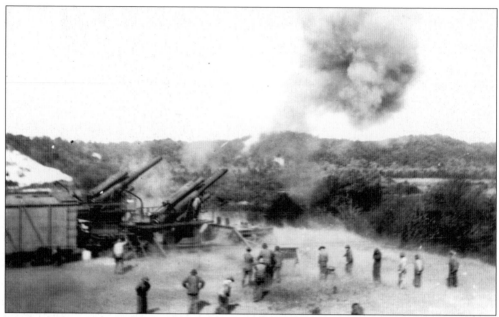

WORLD WAR I TRAINING AT PROVINCETOWN, 1918. These two photographs show some of the special rail-car-mounted artillery used in training at Provincetown during World War I. They are not actually firing at anything, but rather shooting blanks. (Courtesy of Howard Goodwin.)

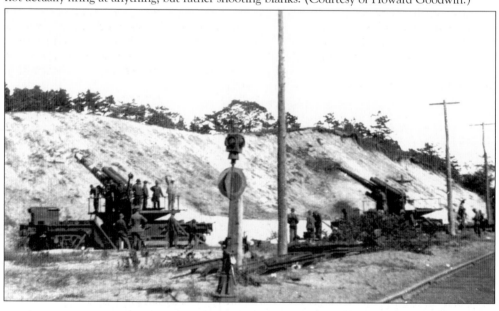

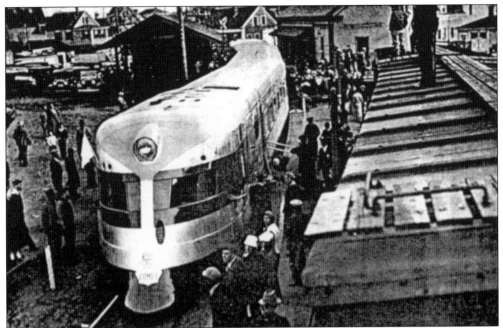

THE COMET AT PROVINCETOWN, 1935. The Goodyear Zeppelin Company of Akron, Ohio, a joint American-German company formed to construct airships, built the *Comet*, a three-car articulated lightweight train, for the New Haven Railroad in 1934–1935. In April 1935, this train reached a record speed of 109.1 miles per hour between Boston and Providence, the run for which it was originally intended. The *Comet* was unique, and the New Haven displayed it all across the system while new, including this visit to Provincetown in 1935. The *Comet* remained in service for 16 years, until making its last trip on September 29, 1951, before being scrapped in 1952. (Courtesy of Howard Goodwin.)

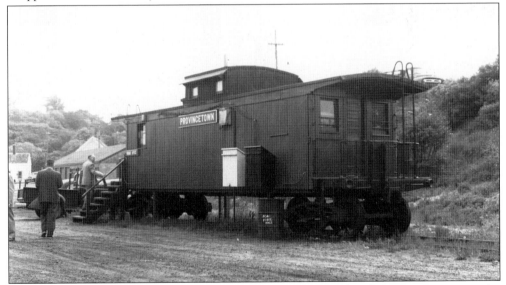

A CABOOSE STATION AT PROVINCETOWN. This caboose was placed in Provincetown in the 1950s to serve as the freight agent's office. (New Haven Railroad photograph by Charles Gunn, courtesy of William Reidy.)

OLD COLONY R.R.

WEEK-DAY TRAINS.

No. of Train	DEPARTURES		No. of Train	ARRIVALS	
		A.M.			A.M.
1	So. Braintree Local Freight (Mondays except'd) leaves So. Boston,	12.01	2	So. Braintree Local Freight (Mondays excepted),	5.00
7	Fall River Local Freight leaves South Boston,	6.00	4	Taunton Local Freight (Mondays excepted),	5.15
9	Shawmut, Pass.	6.25	6	Cape Cod Express Freight,	5.50
11	So. Braintree, Shawmut & Granite,	6.45	10	Shawmut, Pass.	6.30
17	Shawmut,	7.25	12	Campello, So. Braintree & Granite,	6.35
19	S.S., D. & C. & Plymouth,	7.35	14	F.R. & New York Steamboat,	6.50
21	Middleboro & Plymouth,	7.50	20	So. Abington & Shawmut,	7.16
25	Fall River & Taunton,	8.00	22	Shawmut,	7.44
27	Shawmut,	8.05	24	So. Braintree & Granite,	7.50
29	Newport & N. B., Cape Cod, & Vineyard Exp.,	8.30	26	Middleboro, No. Easton & S.S. & Marshfield,	7.55
33	Nantasket Beach, S.S., Marshfield & Granite,	8.33	28	So. Braintree,	8.10
35	Shawmut,	9.03	30	Plymouth,	8.15
37	Milton Local Freight,	9.40	32	Shawmut Express,	8.23
39	Campello and Granite, Pass.	10.05	34	Braintree & Granite,	8.33
41	Plymouth Local Freight,	10.12	36	D. & C. & So. Shore,	8.40
43	Shawmut, Pass.	10.50	38	Milton Express,	8.49
45	So. Abington & Bridge. Br.,	11.00	40	Fall River, Taunton & Middleboro,	8.56
49	Newport, N.B. & So. Shore & Marshfield,	11.40	42	New Bedford & Taunton & So. Abington Express,	9.05
53	Taunton & Middleboro Express Freight,	11.45	44	Plymouth & Duxbury Express,	9.12
		M.	46	Shawmut,	9.20
55	So. Braintree, Pass.	12.00	48	Limited Express (Private Train),	9.25
		P.M.	50	Braintree & Granite,	9.45
57	Granite,	12.30	58	Newport, Fall River & Taunton Express,	9.55
59	Vineyard, Nantucket, Hyannis & Middleboro Exp.,	12.45	60	Cape Cod, Vineyard & Fairhaven Express,	10.05
61	Shawmut,	1.00	62	So. Braintree,	10.25
65	South Braintree,	1.15	64	Cape Cod & Middleboro,	10.30
73	New York Express Freight,	1.30	66	Shawmut,	10.39
75	So. Braintree, Pass.	1.50	70	Taunton & New Bedford & Plymouth Express,	10.48
77	New Bedford, Taunton & Campello Express,	2.15	72	So. Braintree & So. Shore,	11.05
79	Plymouth, S.S. & Granite,	2.30	74	New York Express Freight,	11.22
83	Shawmut,	3.00	80	Granite, Pass.	11.37
85	Limited Express (Private Train),	3.10			P.M.
87	Cape Cod & Middleboro,	3.15	82	Milton Local Freight,	12.25
91	Newport & Fall River & So. Abington Express,	3.35	88	Shawmut, Pass.	12.53
97	Plymouth & Duxbury Express,	3.50	90	Newport, Fall River & New Bedford,	1.00
99	Cape Cod & Fairhaven & Vineyard Express,	4.10	92	Plymouth & So. Abington,	1.20
101	Randolph,	4.15	94	Vineyard, Nantucket & Hyannis Express,	1.25
103	Braintree, Granite, & Shawmut,	4.20	100	So. Braintree, So. Shore, Marshfield & Granite,	2.05
105	Middleboro & Fall River,	4.35	102	Shawmut,	2.23
107	Taunton, F.R. & N.B. Express,	4.45	106	Campello,	3.14
109	So. Braintree,	4.48	108	Campello, So. Shore, Marshfield & Shawmut,	4.25
111	Shawmut,	5.00	110	Fall River Local Freight,	4.40
113	Plymouth,	5.10	112	Plymouth & So. Shore, Pass.	5.17
115	Middleboro & D. & C.,	5.20	114	Milton,	5.28
117	Shawmut Express,	5.25	118	Middleboro,	5.35
119	South Shore & Granite Express,	5.30	120	Newport & New Bedford & Vineyard,	5.43
121	So. Braintree,	5.32	122	So. Braintree & Granite,	6.08
125	F.R., N.B. & New York Steamboat Express,	6.00	124	Shawmut,	6.20
133	Shawmut Express,	6.03	128	Plymouth, D. & C. & So. Shore & Granite,	7.00
135	Middleboro' & No. Easton,	6.07	130	Newport, C.C. & N. B. & Vineyard & Nantucket,	7.10
137	So. Braintree,	6.12	132	Middleboro,	7.25
139	S.S., Marshfield, So. Abington & Granite,	6.25	136	Shawmut,	7.32
141	Shawmut,	6.30	138	So. Braintree,	7.45
143	So. Braintree,	7.10	140	Shawmut,	8.22
145	Shawmut,	8.00	142	D. & C. & So. Shore Local Freight	8.35
147	Campello & So. Braintree,	8.15	144	Fall River Express Freight,	9.10
149	Taunton Local Freight leaves South Boston,	8.30	148	So. Braintree, Pass.	9.20
151	Harrison Square, Pass.	9.00	150	Shawmut,	9.45
153	So. Braintree & Shawmut,	10.00	152	Plymouth Local Freight,	9.55
153	So. Abington & Bridge. Br., (Tues. & Fri. only),	10.00	156	So. Abington & Bridge. Br., (Tues. & Fri. only), Pass.	10.30
157	D. & C. & South Shore Local Freight leaves So. Boston,	10.15	158	Nantasket Beach & So. Shore Express,	10.40
159	Harrison Square, Pass.	10.45	160	So. Braintree,	10.58
161	Campello,	11.10	162	Shawmut,	11.15
163	So. Braintree & Shawmut,	11.15			
165	F.R. & C.C. Express Freight,	11.20			

SUNDAY TRAINS.

No. of Train	DEPARTURES		No. of Train	ARRIVALS	
		A.M.			A.M.
167	So. Braintree Local Freight leaves South Boston,	12.01	168	So. Braintree Local Freight,	5.00
169	Vineyard, Nantucket & Hyannis Express, Pass.	7.30	170	Taunton Local Freight,	5.15
171	So. Braintree,	8.30	172	New York, Taunton & Fall River Steamboat, Pass.	7.05
173	Plymouth, Duxbury & Cohasset & S.S.,	9.15	176	Fall River & Middleboro & So. Abington,	9.40
		P.M.	180	So. Braintree,	10.10
175	So. Braintree,	12.45			P.M.
177	Nantasket Beach & So. Shore,	1.30	182	So. Braintree,	2.25
179	So. Braintree,	5.00	184	Plymouth, D. & C. & So. Shore,	6.03
183	Fall River & Middleboro & So. Abington,	5.45	186	So. Braintree,	6.40
187	Fall River & New York Steamboat Express,	7.00	188	Nantucket, Vineyard & Hyannis Express,	8.30
189	So. Braintree,	10.00	190	Nantasket Beach & South Shore,	10.46
			192	So. Braintree,	11.30

Geo. H. Ellis, Printer. 141 Franklin St., Boston.

AN OLD COLONY RAILROAD TIMETABLE, JUNE 23, 1884. In this poster, note the trains numbered 48 and 85: "Limited Express (Private Train)." This was the *Dude*, which made its first run on June 23, 1884. (Courtesy of William Reidy.)

Four

THE WOODS
HOLE BRANCH

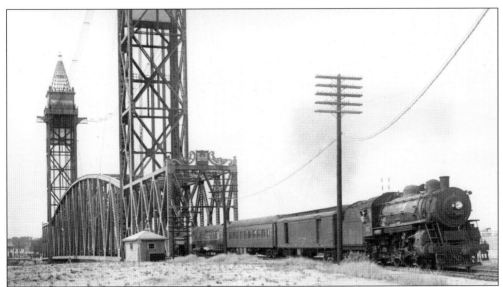

THE WOODS HOLE SECTION, THE *DAY CAPE CODDER*, JULY 9, 1939. The *Day Cape Codder* crosses the bridge to head down the Woods Hole branch, led by New Haven locomotive No. 1342, an I-2 Pacific class. (Courtesy of Howard Goodwin.)

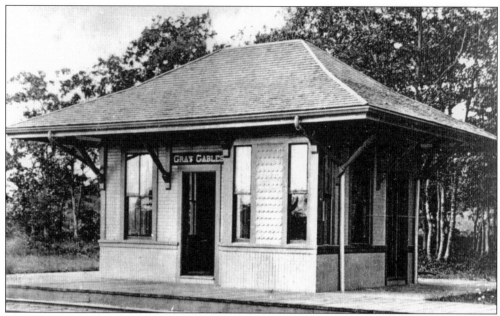

THE GRAY GABLES STATION. This station, named for Pres. Grover Cleveland's nearby summer home, was constructed in 1892. Although he frequently traveled by presidential yacht to his summer property on the Cape, he was not known to travel by train. This station was retired from use *c.* 1940 and is now a museum on the grounds of the Aptuxcet Trading Post. (Courtesy of Howard Goodwin.)

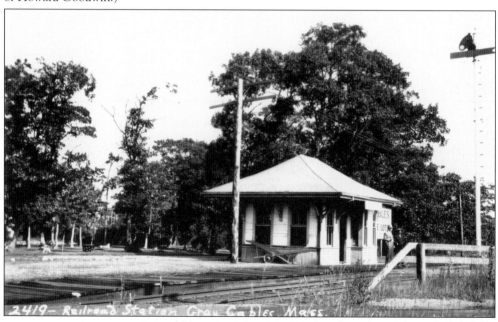

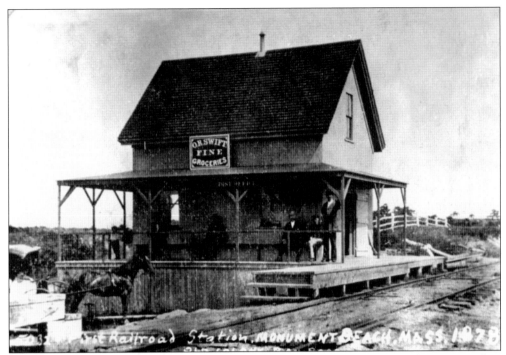

THE ORIGINAL MONUMENT BEACH STATION. This building was constructed by O.R. Swift in 1875 and served as the station until the railroad built its own in 1883. Swift operated a grocery store, and this building also housed the post office and freight and express offices, in addition to selling tickets for the railroad. (Courtesy of the Bourne Archives.)

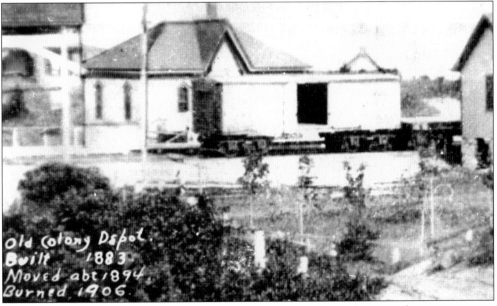

THE SECOND STATION FOR MONUMENT BEACH. This building, the second station to serve Monument Beach, was constructed in 1883. By 1894, the railroad had moved it to the site of the current Monument Beach station. This structure was destroyed in a spectacular 1906 fire and was replaced by the brick building that survives today. (Courtesy of Howard Goodwin.)

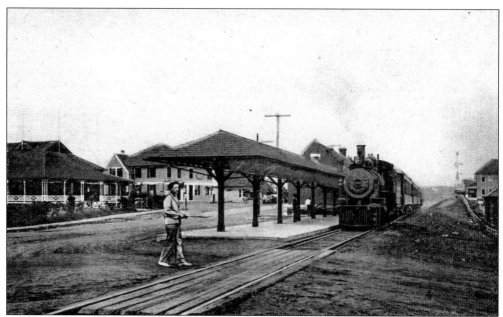

AT THE STATION, MONUMENT BEACH. This train, shown stopped at the Monument Beach station, is headed toward Buzzards Bay, where it will probably continue on to Boston. Monument Beach was the second station on the Woods Hole branch. Now approaching its centennial, it remains in the exact same location. (Courtesy of Howard Goodwin.)

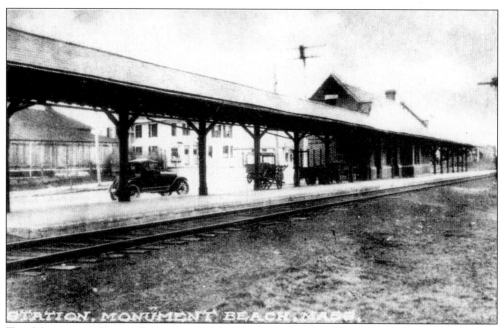

THE MONUMENT BEACH STATION, 1908. The station pictured here was the second to occupy this spot. It was constructed in 1906 after a fire destroyed half the village of Monument Beach. Today, this station is a private residence with some additions, but it still resembles its appearance in this postcard view. (Courtesy of Howard Goodwin.)

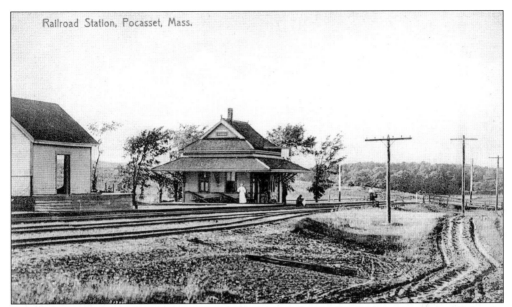

THE POCASSET RAILROAD STATION. This postcard shows the Pocasset station and freight house on the Woods Hole branch. The station was originally called Wenaumet, and the Pocasset station was about one mile farther down the tracks. When the Pocasset station was moved farther down the line to Cataumet, to serve as the freight house there, this station was renamed Pocasset. It burned down on May 20, 1914, but a new one was built in 1915 on the same site. This new Pocasset station was demolished in 1960, although remnants of the foundation and platform are still visible. (Courtesy of Howard Goodwin.)

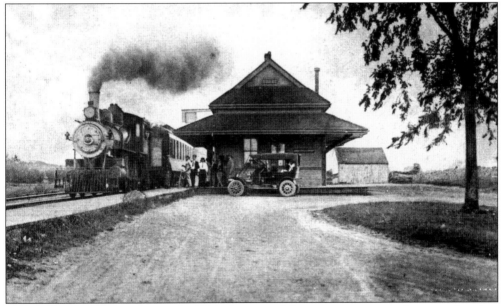

THE POCASSET STATION, 1914. In 1906, the original Pocasset station was taken out of service, and this stop was renamed Pocasset. The station pictured here was built in 1872 and stood until May 20, 1914, when it succumbed to fire. A replacement station was built here in 1915. (Courtesy of Howard Goodwin.)

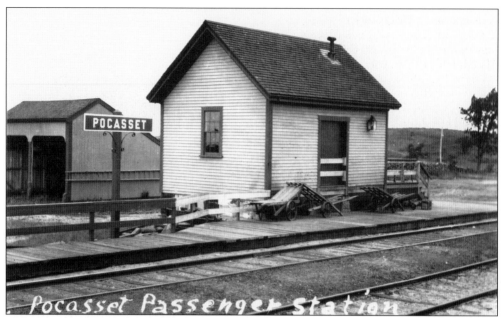

Pocasset Passenger Station

THE POCASSET FREIGHT HOUSE, 1914. After the Pocasset station burned down in May 1914, this freight house served a dual role as temporary passenger station and freight house, until a new station could be constructed the following year. (Photograph by Louis H. Benton, courtesy of Howard Goodwin.)

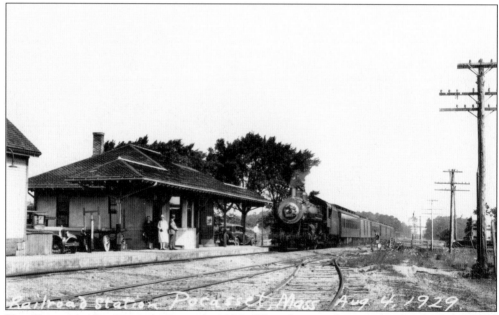

Railroad Station Pocasset, Mass Aug 4 1929

THE POCASSET STATION, AUGUST 4, 1929. This photograph captures the third and final station at Pocasset. It was built in 1915 to replace the previous structure (which burned) and remained until 1960, when it was demolished. A corner of the freight house is also visible to the left. (Photograph by Louis H. Benton, courtesy of Howard Goodwin.)

THE ORIGINAL STATION AT CATAUMET. The first Cataumet station was built in 1890 (18 years after the Woods Hole branch opened) but burned down in 1925. Note the ornate gingerbread trim on this station, making it unique on the Cape. (Courtesy of Howard Goodwin.)

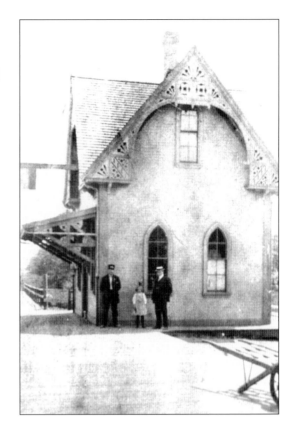

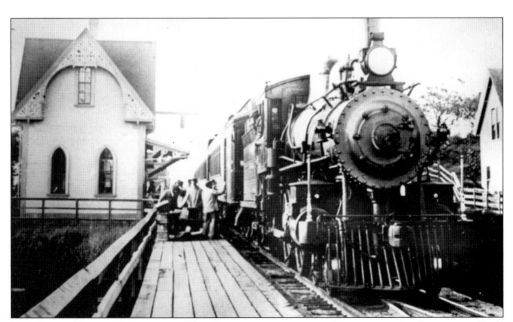

THE DUDE TRAIN, CATAUMET. The Cataumet station was always a stop for the private *Dude* train. (Courtesy of Howard Goodwin.)

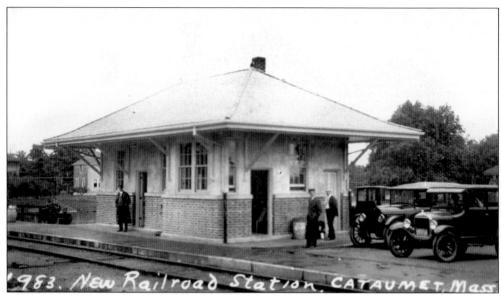

1983. New Railroad Station, CATAUMET, Mass

The Cataumet Station, 1930. The original station at Cataumet, with its ornate gingerbread detail, was constructed in 1890. After that station burned down in 1925, it was replaced by this structure, which still stands today. (Photograph by Louis H. Benton, courtesy of Howard Goodwin.)

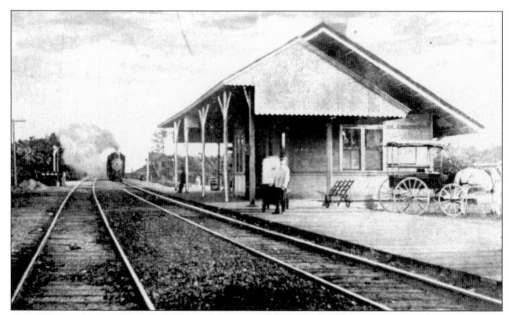

The North Falmouth Station. This view of the North Falmouth station features a train pulling in. (Courtesy of Howard Goodwin.)

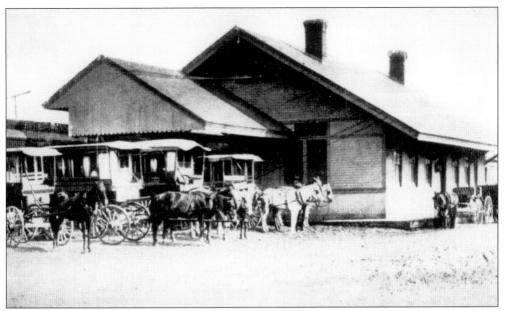

THE SECOND NORTH FALMOUTH STATION. This photograph captures the second station at North Falmouth shortly after its 1905 construction. There are plenty of horse-drawn carriages on hand to meet the train on this day, and the size of the station suggests it was a busy stop for the railroad. This station burned down in 1969, just a few years after the end of New Haven passenger service on this line. (Courtesy of Howard Goodwin.)

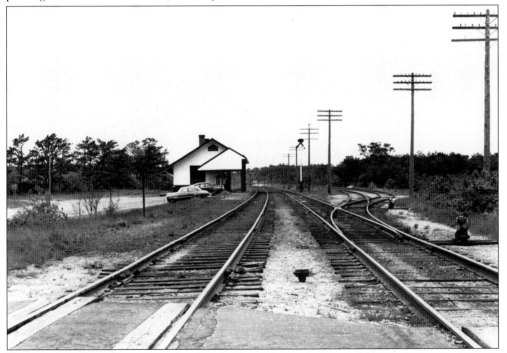

THE NORTH FALMOUTH STATION, JUNE 9, 1955. The station at North Falmouth was built by the New Haven Railroad in 1905. (New Haven Railroad photograph by Charles Gunn, courtesy of William Reidy.)

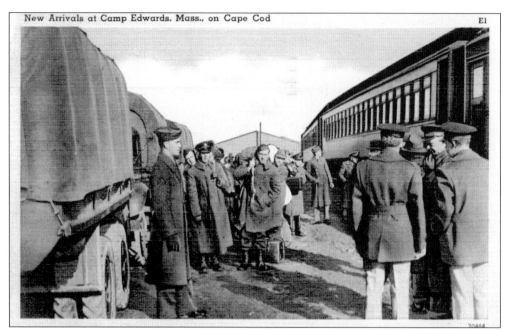

A TROOP TRAIN AT CAMP EDWARDS. During wartime, troop trains were common on the Cape to Camp Edwards, in Sandwich, and to Camp Wellfleet, in South Wellfleet.

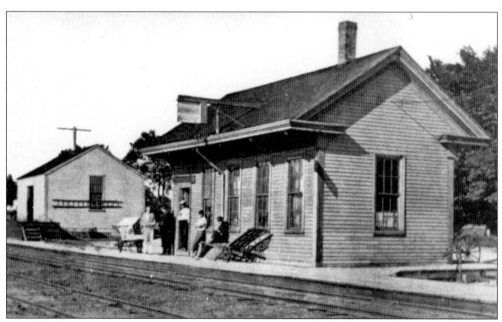

THE WEST FALMOUTH STATION, 1910. A few people are waiting for the train to arrive in this view of West Falmouth. The freight house is visible to the left of the station. The tracks were originally laid here in 1872, and although this station is now gone, the tracks remain. (Courtesy of Howard Goodwin.)

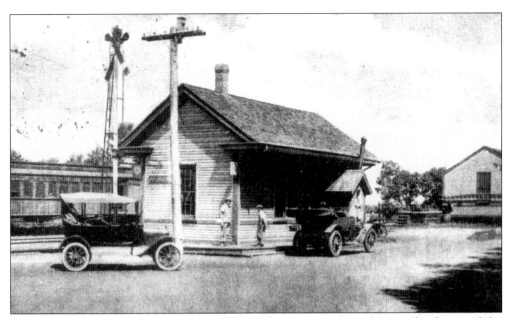

THE WEST FALMOUTH STATION, 1920. Here is the same station with a couple of automobiles waiting to pick up passengers at West Falmouth. Part of the freight house can be seen in this view. (Courtesy of Howard Goodwin.)

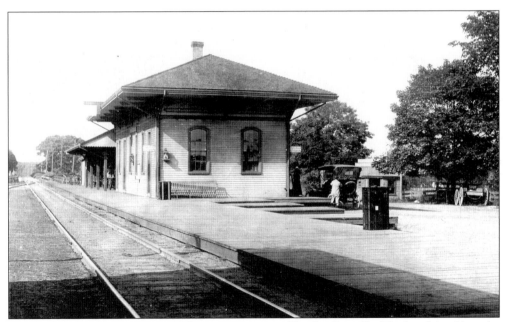

THE OLD FALMOUTH STATION. This station was used by the Cape Cod Railroad (and later by the Old Colony and New Haven Railroads) from 1872 until 1912. In this view, the canopy on the south side of the station has apparently been removed, possibly signaling imminent replacement of the station. (Courtesy of Howard Goodwin.)

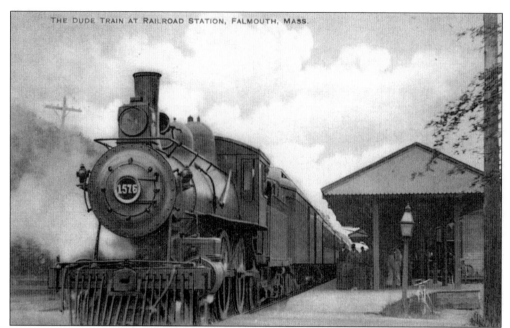

THE *DUDE* TRAIN AT FALMOUTH, C. 1911. This postcard view depicts the *Dude* train at Falmouth. At this point, it has just over three miles left in its journey and one final stop to make at Woods Hole. The *Dude* operated from 1884 through 1916. The station pictured is the old Falmouth station, which was replaced by the current one in 1912. (Courtesy of Howard Goodwin.)

THE FALMOUTH RAILROAD STATION. The station in this photograph dates from 1912, and judging from the automobiles in front of it, this photograph is probably of that vintage. In 1989, after years of neglect, the station was refurbished at a cost of $1 million. (Courtesy of Howard Goodwin.)

THE FALMOUTH RAILROAD STATION, C. THE 1930S. This photograph shows the Falmouth station with its canopies. (Photograph by Louis H. Benton, courtesy of Howard Goodwin.)

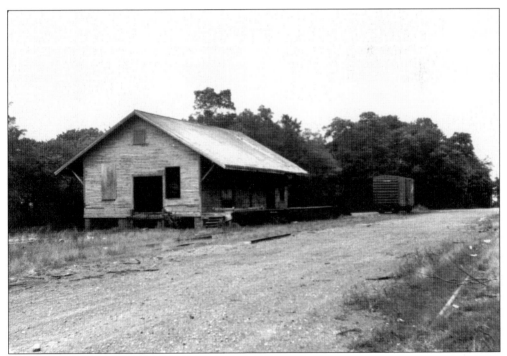

THE FALMOUTH FREIGHT HOUSE. The Falmouth freight house is in poor condition in this photograph, possibly as recent as the 1970s. (Courtesy of Howard Goodwin.)

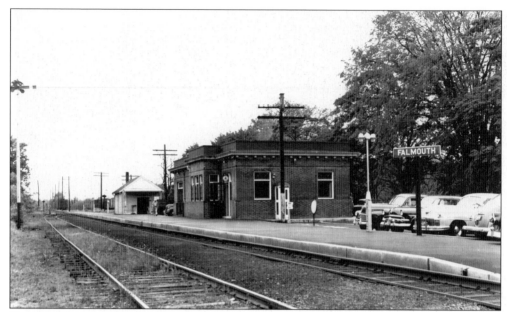

THE FALMOUTH STATION, THE 1950S. This view shows the Falmouth station with the canopies (seen in earlier photographs) removed. This station still stands today, after receiving renovations and upgrades (including a high-level platform) in 1989, although it has not seen any regular passenger service since then. It currently serves as the Falmouth terminus for Bonanza bus service. (New Haven Railroad photograph by Charles Gunn, courtesy of William Reidy.)

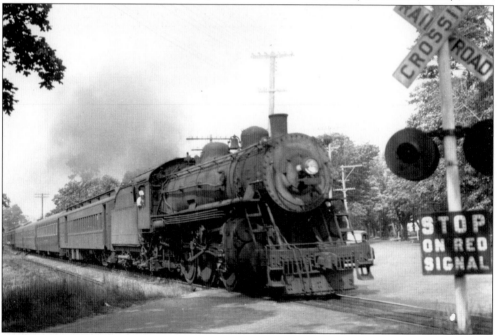

ON THE WOODS HOLE BRANCH, 1947. A New Haven I-2 Pacific-type locomotive is leading a good-size train (at least seven cars are visible here) across Locust Street, between Falmouth and Woods Hole. The Shining Sea bike path now occupies the railroad right-of-way at this location. (Courtesy of Philip H. Choate.)

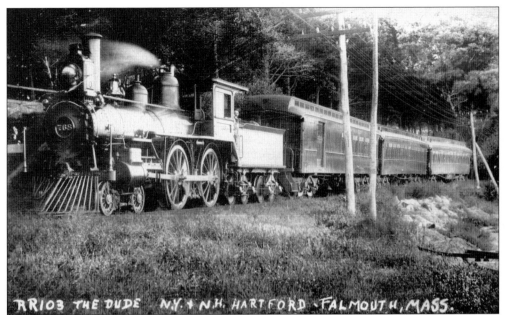

THE DUDE, WOODS HOLE. The *Dude* (sometimes also referred to as the *Flying Dude*) was a private subscription train that ran between Boston and Woods Hole from 1884 through 1916. The train was chartered by a group of wealthy Boston businessmen who desired a faster way to travel to their summer homes on the Cape, and the New Haven was able to provide it—for the right price. The regular schedule for this run was 2 hours and 50 minutes, while the *Dude* accomplished it in just 1 hour and 40 minutes. (Courtesy of Howard Goodwin.)

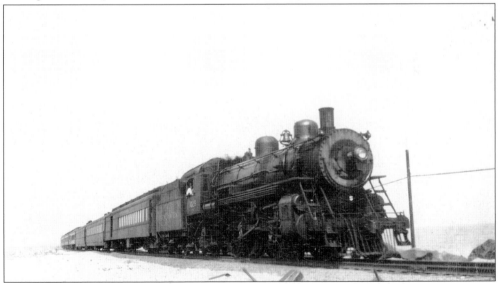

A NEW HAVEN I-1 PACIFIC ON THE WOODS HOLE BRANCH, AUGUST 1946. No. 1029 was one of 21 I-1-class Pacifics built by the Baldwin Locomotive Works for the New Haven. It is shown leading the *Cape Codder* between Falmouth and Woods Hole. Engineer Johnny Sylver was making the run on this day, along with fireman Jack Pierce. The New Haven Railroad acquired a total of 32 I-1s between 1907 and 1910, and all 32 survived into the 1940s, with 10 still in service in 1950. (Courtesy of Allen F. Speight.)

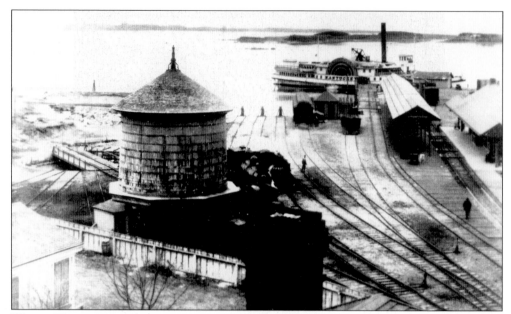

WOODS HOLE, 1902. The importance of the railroad to the village of Woods Hole can be seen in this photograph. The turntable to the left was still in use, but the roundhouse it served was gone. The sidewheel steamer *Nantucket* is docked at the wharf, and this view gives a good perspective of the convenience for passengers transferring between rail and boat. Today, this area provides asphalt parking lots for the island ferries. (Courtesy of Howard Goodwin.)

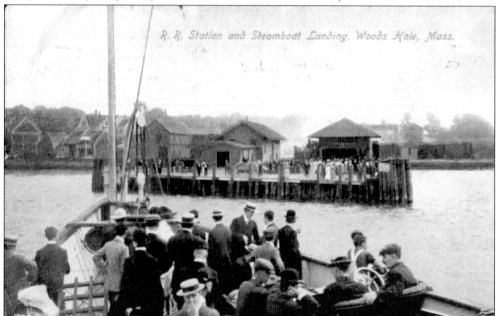

ARRIVING AT WOODS HOLE, THE EARLY 1900S. Woods Hole is seen from the boat. The crowd on the wharf likely just arrived on the train visible near the center. The railroad water tank is barely visible to the right. The railroad served Woods Hole for 92 years, from 1872 through 1964. Today the Shining Sea bike path occupies part of the railroad right-of-way between here and Falmouth. (Courtesy of Howard Goodwin.)

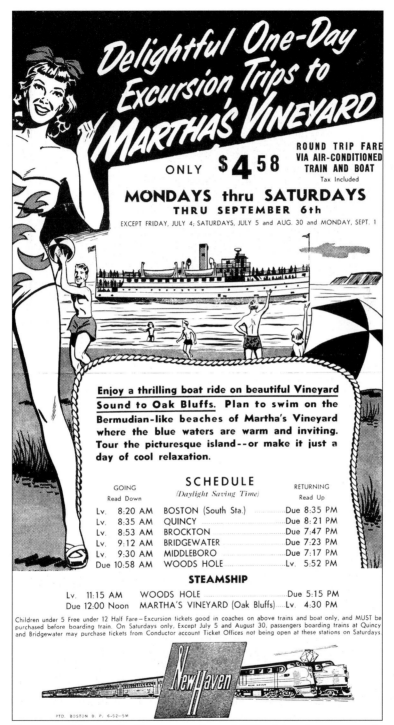

Delightful One-Day Excursion Trips to MARTHA'S VINEYARD

ONLY $4.58

ROUND TRIP FARE VIA AIR-CONDITIONED TRAIN AND BOAT
Tax Included

MONDAYS thru SATURDAYS
THRU SEPTEMBER 6th
EXCEPT FRIDAY, JULY 4; SATURDAYS, JULY 5 and AUG. 30 and MONDAY, SEPT. 1

Enjoy a thrilling boat ride on beautiful Vineyard Sound to Oak Bluffs. Plan to swim on the Bermudian-like beaches of Martha's Vineyard where the blue waters are warm and inviting. Tour the picturesque island--or make it just a day of cool relaxation.

SCHEDULE
(Daylight Saving Time)

GOING Read Down		RETURNING Read Up
Lv. 8:20 AM	BOSTON (South Sta.)	Due 8:35 PM
Lv. 8:35 AM	QUINCY	Due 8:21 PM
Lv. 8:53 AM	BROCKTON	Due 7:47 PM
Lv. 9:12 AM	BRIDGEWATER	Due 7:23 PM
Lv. 9:30 AM	MIDDLEBORO	Due 7:17 PM
Due 10:58 AM	WOODS HOLE	Lv. 5:52 PM

STEAMSHIP

Lv. 11:15 AM	WOODS HOLE	Due 5:15 PM
Due 12:00 Noon	MARTHA'S VINEYARD (Oak Bluffs)	Lv. 4:30 PM

Children under 5 Free under 12 Half Fare – Excursion tickets good in coaches on above trains and boat only, and MUST be purchased before boarding train. On Saturdays only, Except July 5 and August 30, passengers boarding trains at Quincy and Bridgewater may purchase tickets from Conductor account Ticket Offices not being open at these stations on Saturdays.

New Haven

PTD. BOSTON B. P. 6-52-5M

TAKE THE TRAIN TO MARTHA'S VINEYARD, JUNE 1952. Advertisements such as this one from the New Haven were common, promoting train travel to various attractions and events. Also common were tour packages like this one, where $4.58 would buy a round-trip train ticket from Boston to Woods Hole plus a ferry ride to the Vineyard. (Courtesy of William Reidy.)

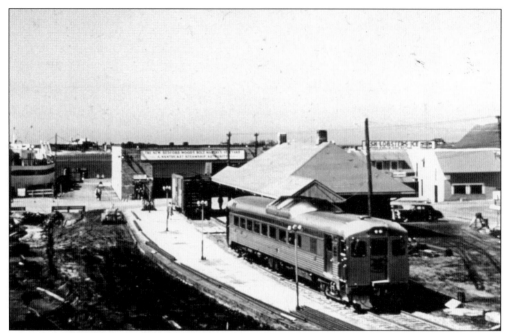

WOODS HOLE, 1963. A lone Budd rail diesel car (RDC) is shown at Woods Hole. The railroad served this village for only one more year. The once vast rail yard is down to a single station track (although a closer inspection reveals two isolated rails embedded in the pavement to the left of the new ferry terminal building). The station, constructed in 1899, lasted but one year after the rails were abandoned and removed, and it was torn down in 1969 to make way for more ferry parking. (Courtesy of Howard Goodwin.)

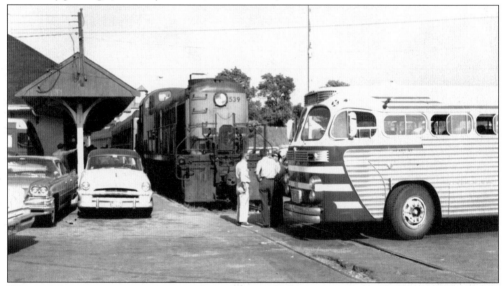

WOODS HOLE, 1960. New Haven Alco RS-3 No. 539 arrives with the Woods Hole section of the *Day Cape Codder* in 1960. Although this popular and profitable service resumed for the 1960 season, after a hiatus the previous year, it continued only for the next four summers. By 1968, the line was formally abandoned, and the tracks were removed. The station, built in 1899, was also torn down when service to Woods Hole ended. (Courtesy of Howard Goodwin.)

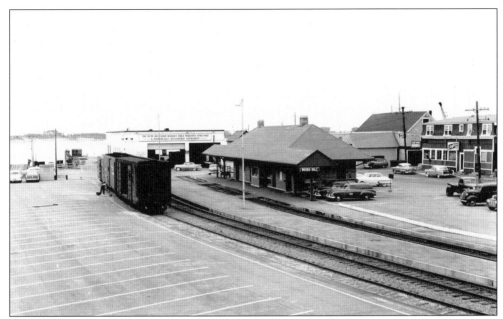

THE WOODS HOLE STATION AND FERRY DOCK, THE 1950S. This view shows the drastic reduction of railroad facilities at Woods Hole. (Courtesy of William Reidy.)

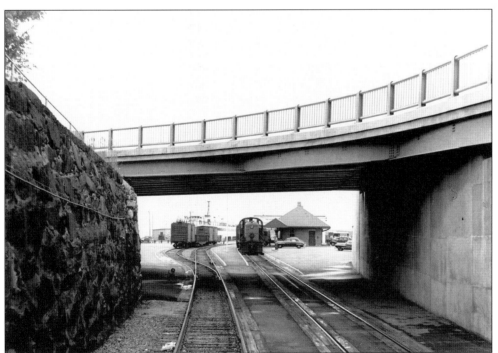

COMING INTO WOODS HOLE, JUNE 9, 1955. Alco RS-2 No. 0513 is ready to lead the passenger train out of the station. Again, notice the extensive asphalt where formerly there was rail. (New Haven Railroad photograph by Charles Gunn, courtesy of William Reidy.)

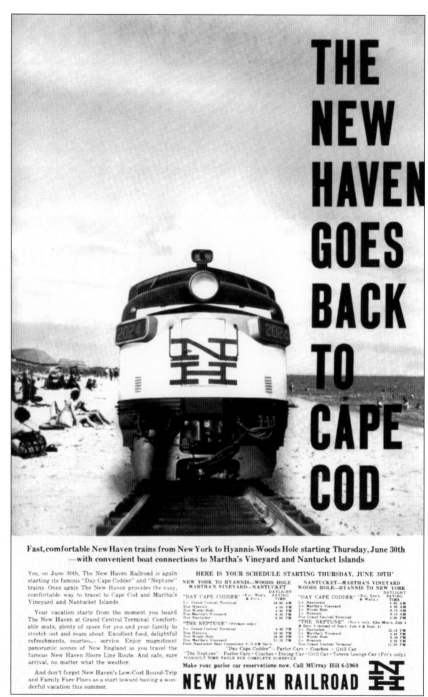

WE'RE BACK! The New Haven Railroad produced this advertisement to announce the resumption of seasonal passenger service in 1960, between New York and Cape Cod, including a direct connection at Woods Hole to the island ferries. After the one-year hiatus in 1959, when there was no rail passenger service of any kind to the Cape, the New Haven brought back this popular and profitable service and continued it through the summer of 1964. (Courtesy of William Reidy.)

Five

THE CHATHAM BRANCH

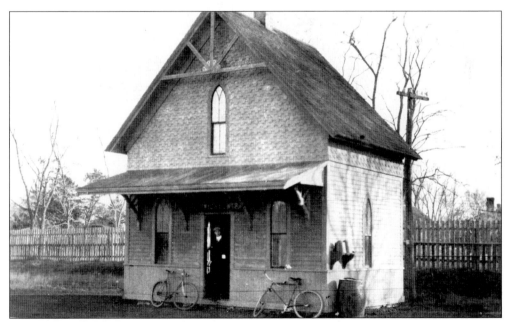

HARWICH CENTRE, 1916. This was the first station on the Chatham branch after Harwich, less than one mile away. Notice the two bicycles in this photograph. One belonged to the station agent (for telegram delivery and other errands). The other belonged to photographer Louis H. Benton. (Courtesy of Howard Goodwin.)

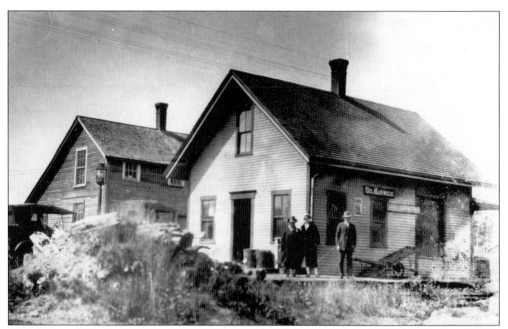

THE SOUTH HARWICH STATION, 1926. The railroad continued to stop at South Harwich, en route between Harwich and Chatham, for 11 more years, until the Chatham branch was abandoned in 1937. (Photograph by Louis H. Benton, courtesy of Howard Goodwin.)

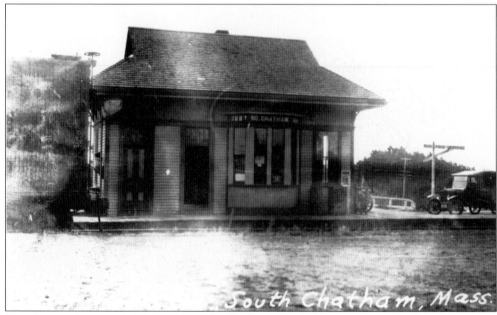

THE SOUTH CHATHAM STATION. South Chatham was the first station west of the downtown Chatham station. It was constructed in 1887, along with the rest of the line. Service on this branch ended in 1937, and the station no longer remains. (Courtesy of Howard Goodwin.)

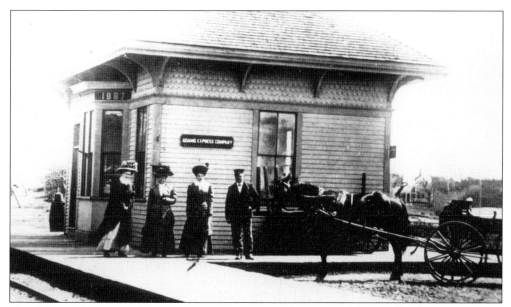

THE SOUTH CHATHAM STATION, 1911. Here is another view of the small station constructed at South Chatham. (Courtesy of Howard Goodwin.)

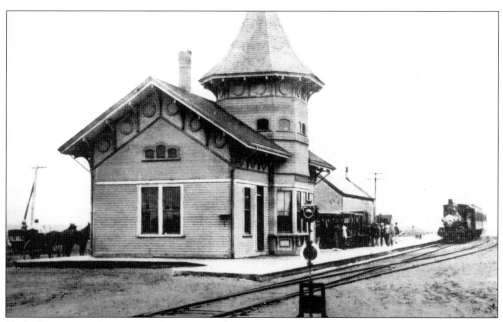

THE CHATHAM RAILROAD STATION. This unique station was constructed in 1887 by the Chatham Railroad Company. This company of town residents constructed the line and built the enginehouse and turntable at Chatham. The Old Colony (and later the New Haven) ran trains on the Chatham branch. This line was the last stretch of railroad to be constructed on the Cape and the first to be abandoned. (Courtesy of Howard Goodwin.)

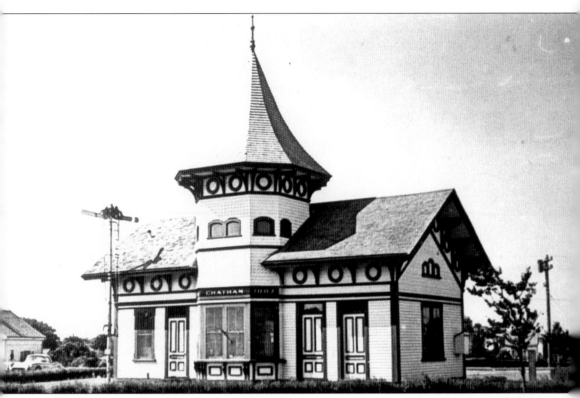

THE CHATHAM RAILROAD STATION. The Chatham station is shown long after the tracks have been removed. Chatham was the last Cape Cod town to receive rail service, with its seven-mile branch completed in 1887. The line was operated for just 50 years and was abandoned in 1937. This station now houses a popular town-operated railroad museum and still looks very much the same. (Courtesy of Howard Goodwin.)

Six

MARTHA'S VINEYARD AND NANTUCKET

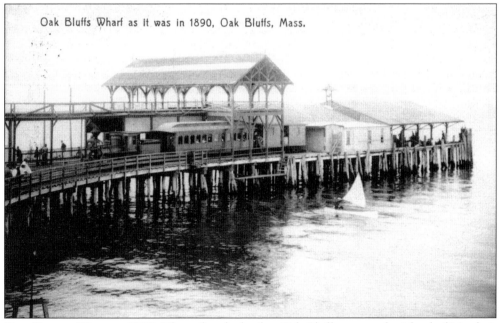

Oak Bluffs Wharf as it was in 1890, Oak Bluffs, Mass.

OAK BLUFFS WHARF, 1890. The railroad wharf at Oak Bluffs was on the island of Martha's Vineyard. The Martha's Vineyard Railroad was constructed in 1874 between here and Katama. In 1876, a half-mile branch to South Beach was added to the line. The line totaled nine miles and was a three-foot narrow-gauge line, like the Nantucket Railroad. The locomotive pictured here is the *Active*, built by the H.K. Porter Company of Pittsburgh. This was the only locomotive used by the Martha's Vineyard Railroad and (with three passenger coaches and one additional car) made up the entire equipment roster. (Courtesy of Howard Goodwin.)

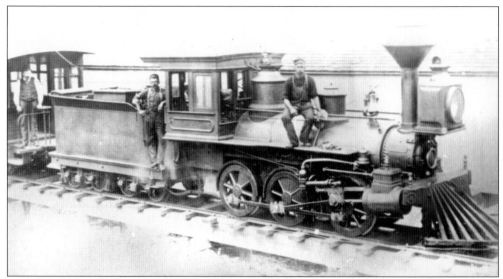

THE MARTHA'S VINEYARD RAILROAD LOCOMOTIVE AT EDGARTOWN, 1890. The Martha's Vineyard Railroad operated from 1874 until 1896. The railroad, delivered to the island in 1874, made it as close as Woods Hole. However, before it was loaded onto the ferry, a cut of cars rolled into the flatcar carrying it. The engine broke free from the flatcar and ended up at the bottom of the harbor, where it spent a couple of days. The Old Colony was able to retrieve it with a crane. After being sent to Old Colony repair shops in Boston, it was once again headed for its new home on Martha's Vineyard, where it arrived safely. This locomotive was named *Active* by its builder but was later named *Edgartown* and, finally, *South Beach*. (Courtesy of Howard Goodwin.)

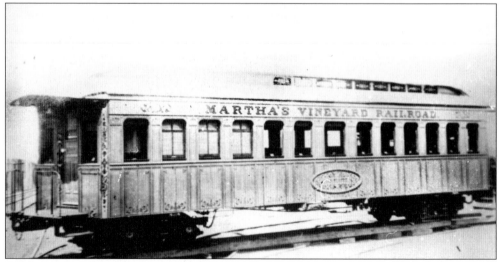

A MARTHA'S VINEYARD RAILROAD COACH. In addition to its one locomotive, the small Martha's Vineyard Railroad owned a grand total of four pieces of rolling stock: three passenger coaches and one baggage car. This coach, named *Oak Bluffs* (the nicest of the three coaches), was constructed by Jackson and Sharpe's Delaware Car Works and was delivered to the island line in 1877. (Courtesy of Howard Goodwin.)

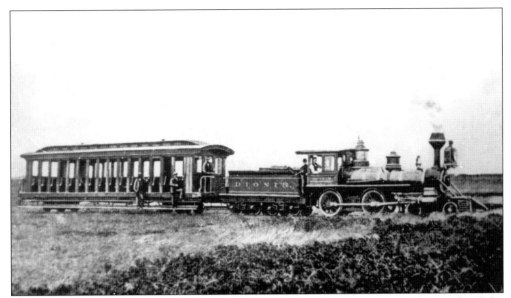

NANTUCKET RAILROAD LOCOMOTIVE *DIONIS*. The first locomotive to ply the rails of the Nantucket Railroad was this 4-4-0, named *Dionis* for the wife of Tristram Coffin, an early Nantucket settler. This locomotive was built by the Baldwin Locomotive Works and originally operated on the Danville, Olney and Ohio River Railroad in Illinois. Reportedly, the island railroad was able to purchase this used locomotive for a bargain price. Like the Martha's Vineyard Railroad, the Nantucket Railroad was a narrow-gauge line. This locomotive operated on Nantucket until 1901. The unique passenger coach in this photograph was one of two of this type acquired from the Long Island Railroad. They had glass partitions on the ends to help protect the passengers from smoke and cinders. There was no center aisle, and all of the seats were reached from the outside via running boards. (Courtesy of Howard Goodwin.)

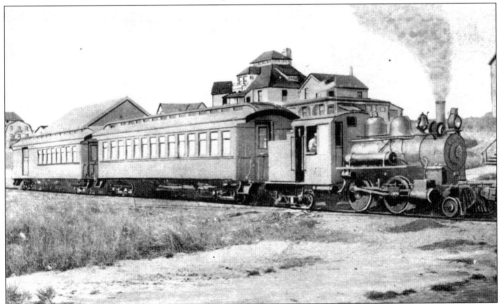

THE NANTUCKET RAILROAD. Locomotive No. 2 and two cars are pictured in this postcard view of the "Siasconset Train" on the Nantucket Railroad. (Author's collection.)

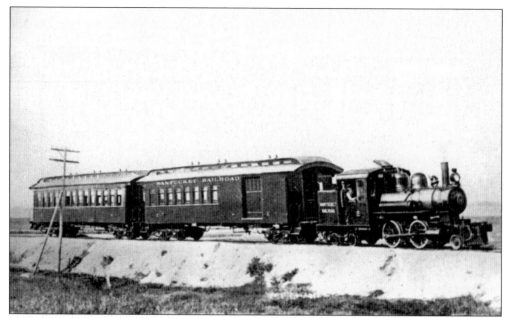

NANTUCKET RAILROAD LOCOMOTIVE NO. 2. This was the last steam locomotive to be acquired by the Nantucket Railroad, arriving on the island in May 1910. It was a 2-4-4T tank-type locomotive, built at the Alco works in Richmond, Virginia, and was the only locomotive to be purchased new by the railroad. At the same time, the railroad placed an order with Jackson and Sharpe of Delaware (the same company that built the coaches of the Martha's Vineyard Railroad) for a combination baggage-passenger car and a regular passenger car. These cars were painted bright red. (Courtesy of Howard Goodwin.)

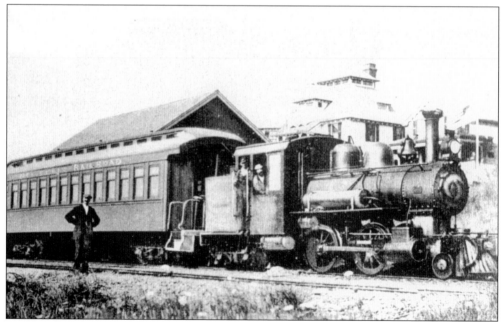

THE NANTUCKET RAILROAD, 1901. This view features Nantucket Railroad locomotive No. 2. (Courtesy of Howard Goodwin.)

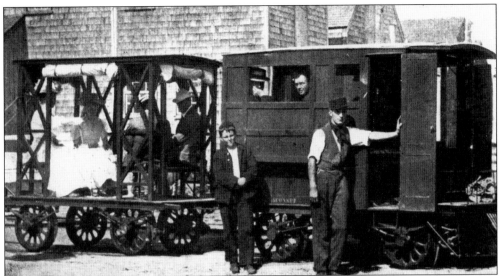

THE NANTUCKET RAILROAD'S SIASCONSET. This gasoline-powered contraption was nicknamed "the bug," and the trailer towed behind it, the "bird cage." This motorcar was built by the Fairbanks-Morse Company, which later tried diesel locomotive building. The motorcar could seat a total of 10 people, including the driver. It arrived on the island in 1907 and was used throughout the winter, regularly running two trips daily between Nantucket and its namesake Siasconset. The trailer was originally intended to carry baggage but could also carry about a half-dozen passengers. The "bug and the bird" continued to operate on the island until 1913, when the bug collided with locomotive No. 2. Its passengers bailed off before the accident and escaped with only minor injuries. (Courtesy of Howard Goodwin.)

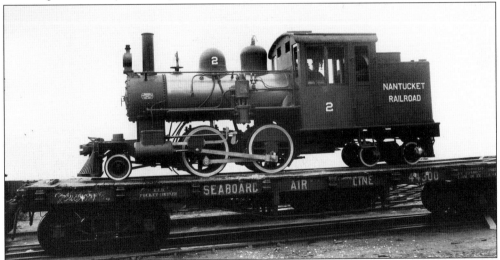

NEW MOTIVE POWER FOR THE NANTUCKET RAILROAD. Nantucket Railroad No. 2 was a three-foot-gauge tank-type locomotive (the tender was part of the locomotive, and not a separate car) built by the American Locomotive Company (Alco). The Nantucket Railroad acquired this locomotive new in 1910 and used it until the railroad's demise at the end of the 1917 season. When the railroad went out of business at the height of World War I, this locomotive (along with the rail and cars used on the island) was sent to Bordeaux, France, to be used by the Allied Expeditionary Forces. (Courtesy of Howard Goodwin.)

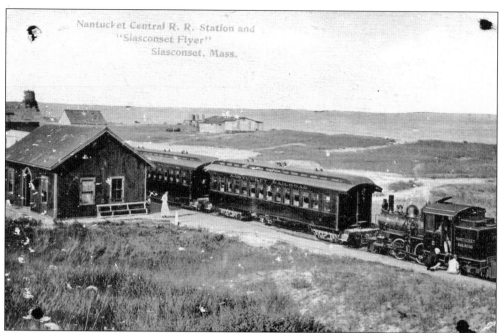

THE NANTUCKET RAILROAD AT SIASCONSET. This postcard view features Nantucket Railroad No. 2 at Siasconset. (Courtesy of the Sandwich Archives.)

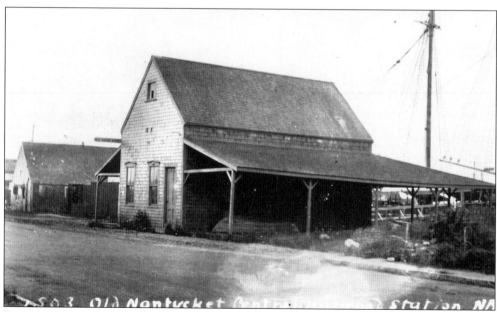

THE NANTUCKET RAILROAD STATION, 1921. Here is the former station of the Nantucket Railroad three years after the line's demise. The sign on the station appears to read, "RR Waiting Room." The tall ship's mast visible behind the station shows the proximity of the harbor. One last Nantucket Railroad car remains on the island, and it has been converted into a popular restaurant. (Photograph by Louis H. Benton, courtesy of Howard Goodwin.)

Seven

MODERN RAILROADS
OF CAPE COD

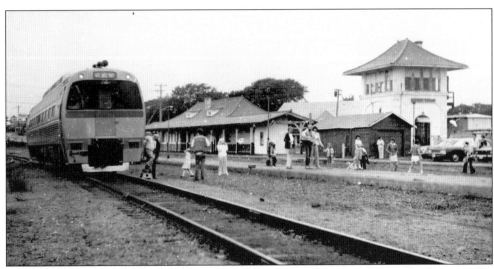

THE NEW ERA OF RAIL TRAVEL? In August 1979, this single self-propelled Budd SPV-2000 made a week-long visit to the Cape, offering free demonstration rides between Buzzards Bay and Falmouth and between Buzzards Bay and Hyannis, with an intermediate stop in Sandwich. Gov. Edward King and U.S. Sen. Paul Tsongas were on hand at a reception in Barnstable to inaugurate this demonstration, and both were strong supporters of returning passenger rail service to southeastern Massachusetts, with the King administration pushing for Cape Cod–to–Braintree rail service by 1982. The modern version of the original RDC (regularly used on the Cape as recently as 1964) is seen here at Buzzards Bay on August 12, 1979. (Courtesy of Howard Goodwin.)

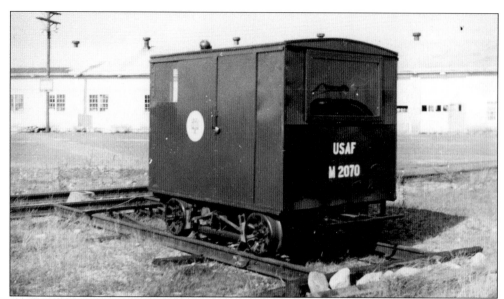

A Track Car at Otis Air Force Base, October 10, 1978. Track cars (also known as speeders) were widely used by track maintenance personnel to get to and from remote locations that needed work, as well as to perform visual track inspections. The U.S. Air Force likely used this one for track maintenance on the base. Today, the high-rail truck (usually a regular pickup truck with small flanged wheels that can be lowered to ride on railroad tracks) has all but replaced track cars such as this. However, many speeders have found new homes with railfans, some of whom bring them to "meets," where they can often be run on a stretch of track—only with permission of the host railroad, of course. (Courtesy of Howard Goodwin.)

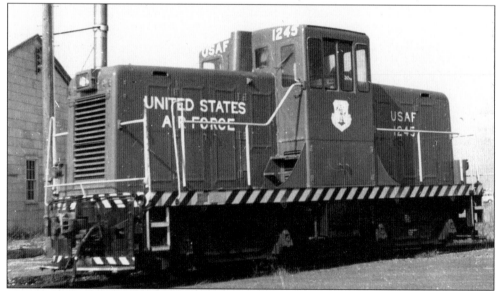

A U.S. Air Force Locomotive at Otis, October 10, 1978. U.S. Air Force No. 1245 was a 44-ton locomotive built by General Electric in 1953. In addition to the time it spent on the Cape, it was also stationed at air force bases ranging from Fort Devens in Ayer to Hill in Ogden, Utah. This unit was acquired by Bay Colony Railroad in 1993 and was sold to the Southern Railroad of New Jersey in 1999. (Courtesy of Howard Goodwin.)

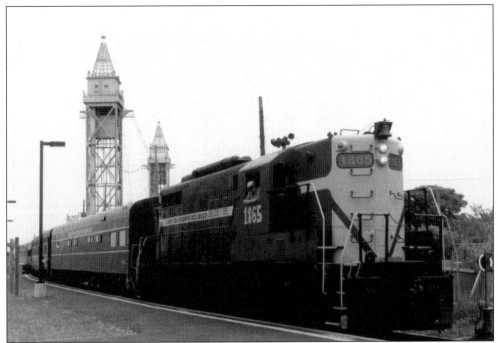

THE CAPE COD AND HYANNIS RAILROAD AT BUZZARDS BAY, THE MID-1980S. A Cape Cod and Hyannis train makes a station stop at Buzzards Bay. Locomotive No. 1865 was a GP-9 built by the Electro Motive Division (EMD) of General Motors. (Courtesy of Doug Scott.)

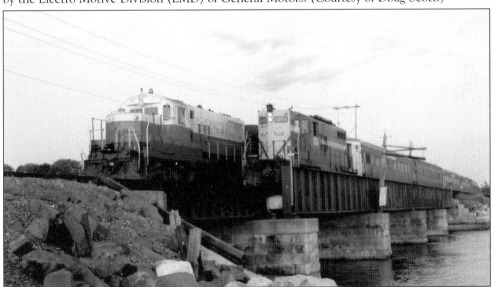

CAPE COD AND HYANNIS AT BUZZARDS BAY. Two trains of the Cape Cod and Hyannis Railroad meet at Cohasset Narrows. Locomotive No. 1353 (left) carries the final paint scheme used by the Cape Cod and Hyannis. No. 1865 has yet to be repainted. Both are facing north, toward Middleboro and Braintree. Most likely, one of these trains (probably the one led by No. 1865) is headed to Braintree, while the other is waiting for its locomotive to run around the train and return to either Hyannis or Falmouth. The Cape Cod and Hyannis operated trains from 1982 until 1989. (Courtesy of Doug Scott.)

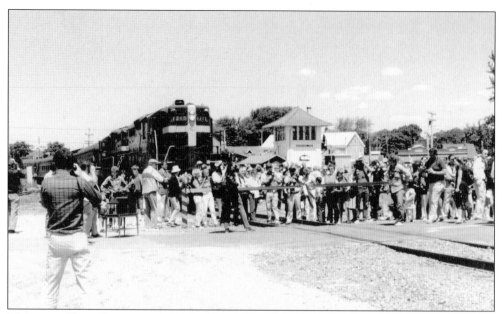

MARITIME DAY FESTIVITIES AT BUZZARDS BAY. On June 15, 1985, the Cape Cod and Hyannis Railroad was on hand at Buzzards Bay to celebrate Maritime Day. The ceremony included a ribbon cutting to rededicate the railroad bridge in its 50th year of service. Cape Cod and Hyannis No. 1210, an EMD GP-9 (its original New Haven number), approaches the bridge. (Courtesy of William Reidy.)

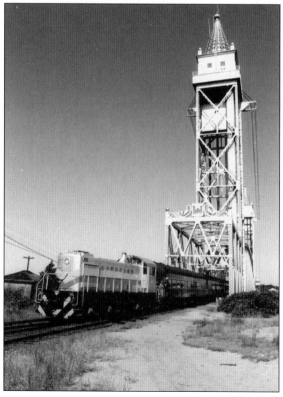

HEADED FOR FALMOUTH, SUMMER 1983. This Cape Cod and Hyannis train behind the borrowed Bay Colony Alco S-1 No. 1061 is heading for Falmouth, having just left Buzzards Bay and having crossed the Cape Cod Canal on the railroad bridge. The year 1983 marked the second season the Cape Cod and Hyannis Railroad served Falmouth. (Courtesy of William Reidy.)

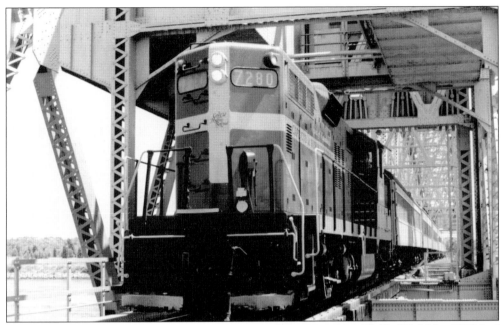

NEW POWER FOR THE CAPE COD AND HYANNIS, JULY 14, 1984. EMD GP-9 No. 1210 had been with the Cape Cod and Hyannis Railroad for about one month when it was photographed here leading a train into Buzzards Bay. It was acquired by the Cape Cod and Hyannis from Conrail, where it was numbered 7280. As the number boards still show its old Conrail number, this unit was probably just painted in Cape Cod and Hyannis colors shortly before this photograph was taken. (Courtesy of William Reidy.)

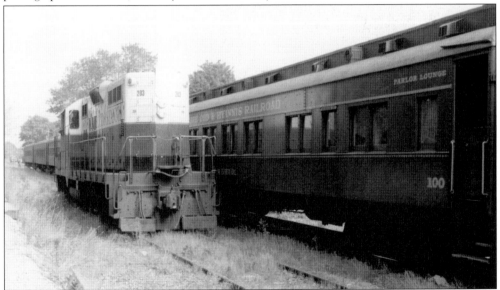

THE RUNAROUND AT FALMOUTH, 1988. Cape Cod and Hyannis Railroad locomotive No. 203 is running around its train at the Falmouth station. Former Pennsylvania Railroad parlor-lounge car *Nobska* (dating from *c.* 1912) is on this train. In its final year of operation (1988), the Cape Cod and Hyannis carried more than 53,000 passengers between Braintree and the Cape, as well as another 6,700 from an Attleboro connection with Amtrak. (Courtesy of Doug Scott.)

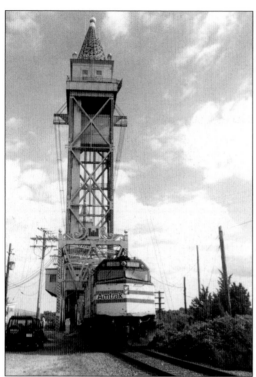

AMTRAK AT BUZZARDS BAY. Amtrak's *Cape Codder* is crossing the railroad bridge at Buzzards Bay on its way back to New York. This train was run by Amtrak from the summer of 1986 through 1996. (Courtesy of Doug Scott.)

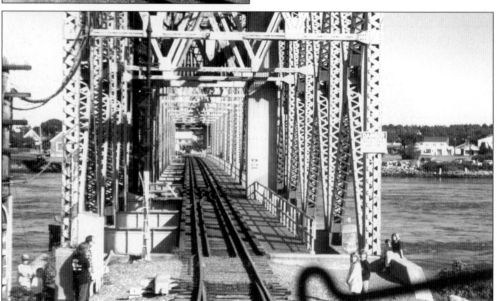

A VIEW FROM THE CAB. This is the view from the cab of an Amtrak F40-PH as it approaches the railroad bridge across the Cape Cod Canal with train No. 271 on its summer Saturday round trip between Hyannis and Providence, Rhode Island. Buzzards Bay is just ahead, on the other side of the bridge. This vertical-lift bridge was constructed between 1933 and 1935 by the Phoenix Bridge Company. The bridge is now undergoing a $30 million restoration project, including paint and structural steel work, cable replacement, and a new control system. (Courtesy of Doug Scott.)

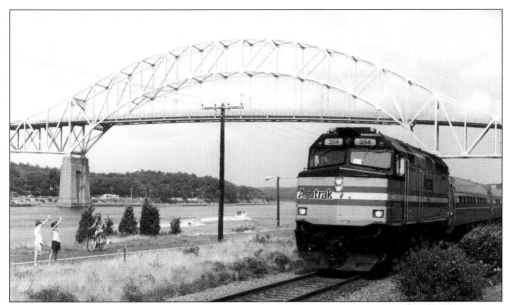

AMTRAK ALONGSIDE THE CAPE COD CANAL, 1995. Amtrak train No. 235, the Sunday afternoon *Cape Codder*, headed from Hyannis to New York, has just passed beneath the Bourne highway bridge and is running alongside the Cape Cod Canal. A couple of people on the canal access road wave and get a friendly toot of the horn and a wave back from engineer Herb Clark, as F40-PH No. 354 leads the train toward Buzzards Bay and New York. (Courtesy of Michael O'Connor.)

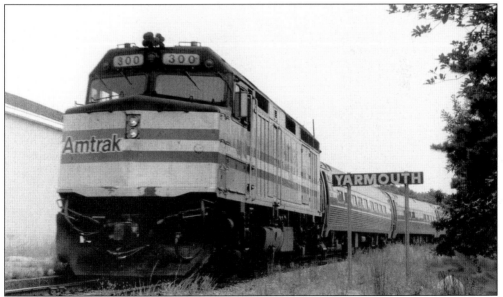

AMTRAK AT THE YARMOUTH WYE, 1988. A regular summertime ritual for Amtrak's *Cape Codder* occurred on Sunday mornings, when the train backed out of Hyannis for three miles to the wye track at Yarmouth. This track, at the junction of the South Dennis branch and the Cape main line to Hyannis, can be used to turn entire trains. Amtrak F40-PH No. 300 is seen here passing the station sign at Yarmouth, shoving its train of Amfleet coaches back to Hyannis in preparation for the afternoon return to New York. (Courtesy of Doug Scott.)

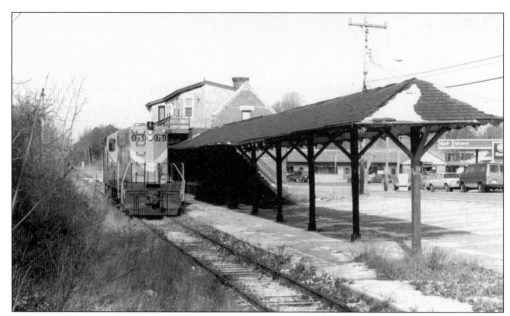

MONUMENT BEACH, DECEMBER 1988. Bay Colony No. 1751 is headed south to Falmouth for switching. It is running light past the Monument Beach station. Despite the additions to it on the trackside, the original structure is still very recognizable. No. 1751 is still in service with Bay Colony, although on the Wattupa branch near Fall River in recent years. (Courtesy of Doug Scott.)

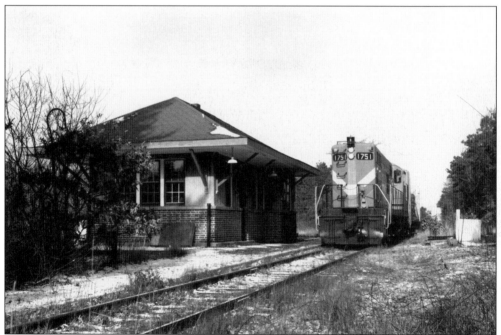

CATAUMET STATION, DECEMBER 1988. No. 1751 is pictured on the Falmouth line, this time headed south with a center-beam flatcar loaded with lumber for delivery to the Wood Lumber Company in Falmouth. (Courtesy of Doug Scott.)

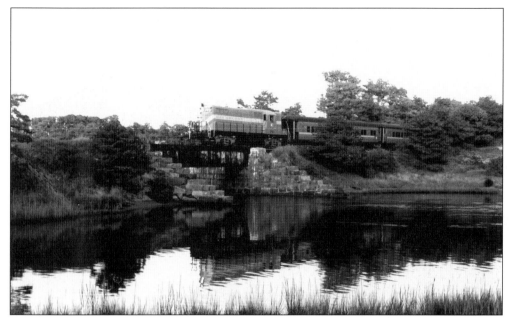

A Bay Colony Railroad Passenger Extra. Bay Colony locomotive No. 1751, a GP-9 model built by EMD, is seen here hauling an extra passenger train across the Bass River bridge. (Courtesy of Doug Scott.)

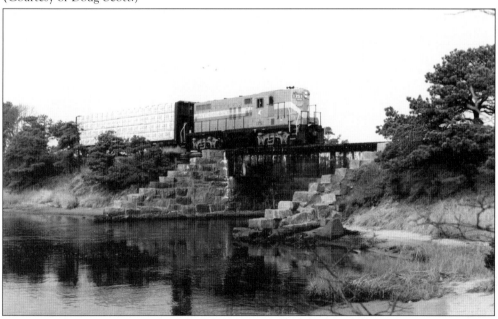

Lumber across Bass River, the Early 1990s. Bay Colony locomotive No. 1751 leads a center-beam flatcar loaded with lumber across the Bass River bridge, destined for the Mid-Cape Home Center lumberyard in South Dennis. Although these tracks still exist, they have been out of service for a number of years between South Yarmouth and South Dennis. Two crossings on this segment of the line, including Station Avenue in South Yarmouth, have been removed. The rails were originally laid here in 1865 as part of the Cape Cod Railroad extension from Yarmouth to Orleans. (Courtesy of Doug Scott.)

BAY COLONY'S INAUGURAL TRASH TRAIN, JUNE 27, 1989. Bay Colony locomotives No. 1501 and No. 1751 are leading a special passenger train across the Back River in Bourne to commemorate the opening of the SEMASS waste-to-energy facility in Rochester. This train was operated from the transfer station at Otis Air Force Base to SEMASS and included a ceremonial first trash car. (Courtesy of Doug Scott.)

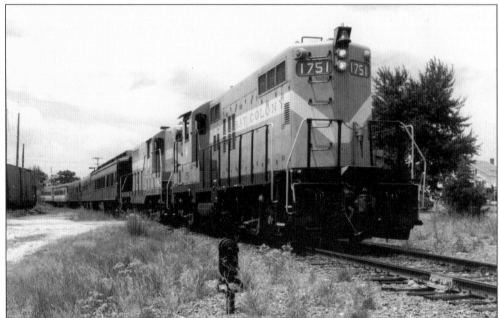

A BAY COLONY PASSENGER EXTRA, JUNE 27, 1989. Locomotives No. 1751 (a GP-9) and sister unit No. 1501 (a GP-7) are about to lead a special passenger train across the railroad bridge at Buzzards Bay. The occasion was the opening of the SEMASS waste-to-energy plant in Rochester. This train will continue to the new trash transfer facility at Otis Air Force Base. (Courtesy of Doug Scott.)

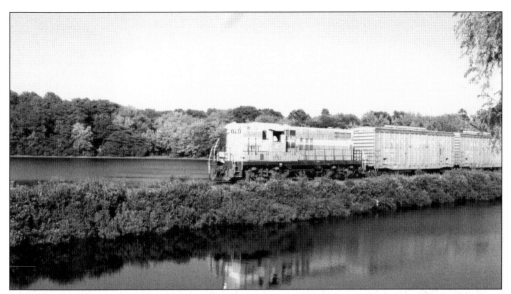

THE TRASH TRAIN AT EAST SANDWICH. With its reflection in Hoxie Pond, Bay Colony GP-9 No. 1751 leads the Yarmouth section of the trash train through East Sandwich. When it reaches the railroad bridge, it will leave these cars there and head down the Falmouth branch to retrieve the trash cars from the transfer facility at Otis Air Force Base. Upon returning to the bridge, the Otis cars will be added to this section, and the entire train will then head to the SEMASS facility. Once the trash cars are tipped there, one at a time, the train will be made up again, and the cars will return to the two Cape transfer facilities the following morning. (Courtesy of Doug Scott.)

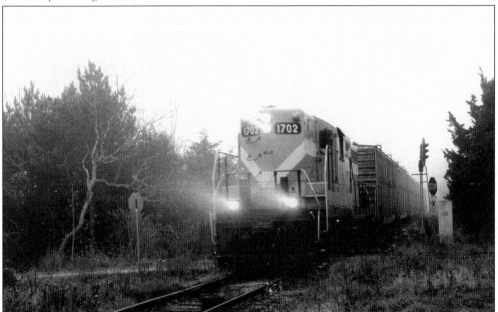

EMERGING FROM THE FOG, NOVEMBER 1998. Bay Colony GP-9 No. 1702 leads the Yarmouth section of the trash train through West Barnstable, seen here at a private grade crossing on a foggy day. The trash trains normally run six days a week and make up the bulk of Bay Colony's freight business on the Cape. (Photograph by the author.)

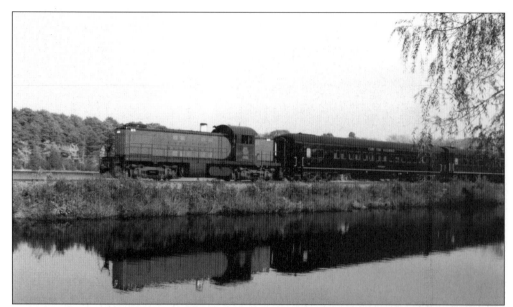

NEW HAVEN IN THE 1990S? In 1989, the Cape Cod Railroad acquired this Alco RS-1 and painted it into the orange-and-green paint scheme of its original owner, the New Haven Railroad, which acquired this unit in 1948. It is seen passing Hoxie Pond in East Sandwich with the dinner train in the early 1990s. (Courtesy of Doug Scott.)

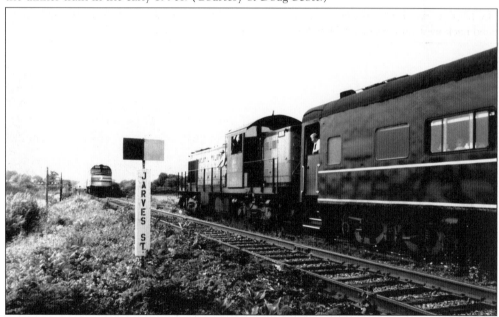

MEET AT SANDWICH. Cape Cod Railroad locomotive No. 0670, painted in the colors of its original owner (the New Haven), has taken the siding at Sandwich to await the approaching Amtrak *Cape Codder*. In the early 1990s, Amtrak ran round trips between Hyannis and Providence on summer Saturdays, in addition to the usual Friday night arrival and Sunday afternoon departure from Hyannis. Once the Amtrak train is clear of Sandwich, the Cape Cod Railroad excursion train will continue on its way to the Cape Cod Canal, where the locomotive will be run around and coupled to the other end for return to Hyannis. (Courtesy of Doug Scott.)

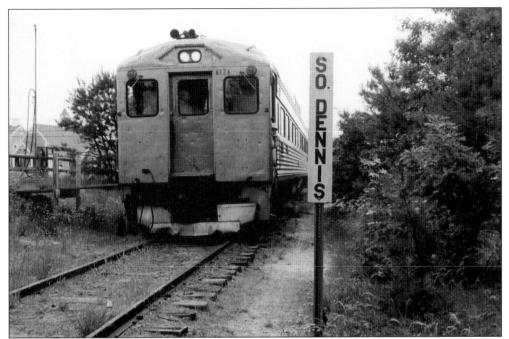

THE END OF THE LINE, JUNE 20, 1993. South Dennis has marked the end of the line since the tracks to Eastham were abandoned in 1965. Here is the Cape Cod Railroad Budd RDC No. 6126 at South Dennis. It has traveled as far east as the tracks go and is now preparing to head back west on a special railfan trip. (Courtesy of Doug Scott.)

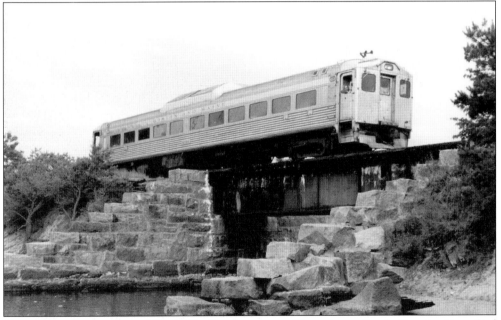

OVER BASS RIVER, JUNE 20, 1993. On the same railfan trip to South Dennis, Cape Cod Railroad Budd RDC No. 6126 crosses Bass River. The Cape Cod Railroad held many railfan trips, which often covered most of the lines between the Cape and Middleboro. (Courtesy of Doug Scott.)

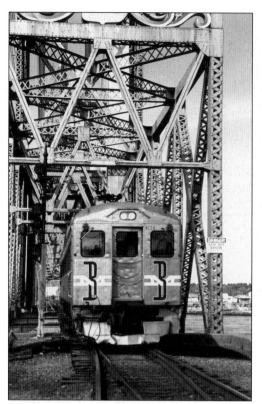

THE CAPE COD RAILROAD CROSSING THE BRIDGE, THE EARLY 1990s. Cape Cod Railroad No. 6126, a Budd-built RDC, crosses the bridge and heads back onto the Cape. Budd cars are completely self-propelled, powered by two on-board diesel engines, and can be operated singly or in multiples. This car is now owned by the Belfast and Moosehead Lake Railroad of Belfast, Maine. (Courtesy of Doug Scott.)

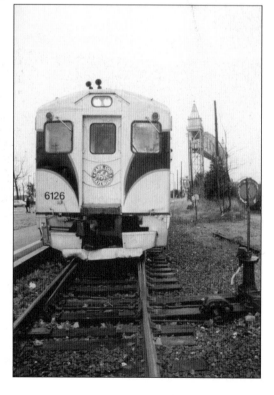

BUDD AT BUZZARDS BAY, THE 1990s. Cape Cod Railroad Budd RDC No. 6126 has ventured off-Cape in this view. The railroad often used this car for special events, including a shuttle between Wareham and the Bourne Scallop Festival, held each September at Buzzards Bay. Here, the car has been repainted into a Cape Cod Railroad scheme, out of its former Boston and Maine colors. (Courtesy of Doug Scott.)

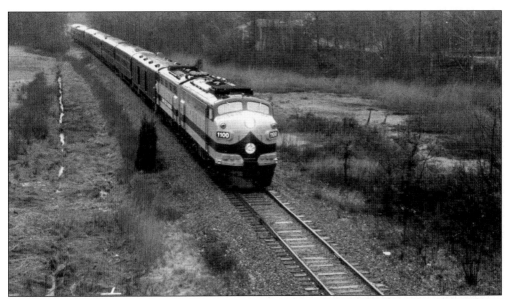

WHEN THEY WERE 'NEW.' On March 7, 1992, the Cape Cod Railroad operated a special passenger extra, celebrating its new locomotives. These two FP-10s (originally EMD F-3s, rebuilt in the late 1970s by Illinois Central) were leased from the Massachusetts Bay Transportation Authority (MBTA) and served the railroad well. Here, No. 1100 and No. 1114 are on the Falmouth line, just south of Monument Beach. Note that No. 1100 had not been fully lettered in time for its inaugural trip. (Courtesy of Doug Scott.)

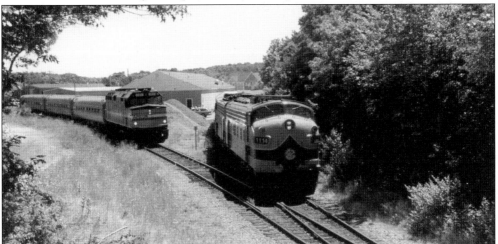

TWO GENERATIONS OF 'F UNITS' MEET. Cape Cod Railroad FP-10s, No. 1114 and No. 1100, lead the afternoon excursion train around the Yarmouth wye as Amtrak F40-PH 273 waits. Once the excursion train has called clear of the wye, Amtrak will be able to pull ahead onto the Cape main line and then shove back to Hyannis, having turned its train around for the afternoon departure of the *Cape Codder*. Ridership suffered with a schedule change that left New York too early on Friday afternoon for many potential passengers to catch it, combined with sharp fare increases in the 1990s. The final blow to the *Cape Codder* service occurred when, in its final year, it was run out of Boston. Passengers coming from Washington, D.C., New York, or New Haven were required to change trains at Providence to complete their journey to the Cape. (Courtesy of Doug Scott.)

THE LAST RUN FOR HERB CLARK. While waiting at Canal Junction for the railroad bridge to be lowered, engineer Herb Clark stands with his son Gary (also an Amtrak engineer) in front of the final Amtrak train he will operate, the Sunday afternoon *Cape Codder,* led by F40-PH No. 206. Herb Clark retired from Amtrak in April 1996, but he came back on August 4, 1996, for one final run on his favorite route. He had a 55-year career with the railroad, first with the New Haven and then with Penn Central, Conrail, and Amtrak. However, he did not stay away from the rails for long, and even in retirement he worked part time at the Cape Cod Railroad. The Clark family has a rich railroad history, beginning with Herb's grandfather, who worked in the White Mountains of New Hampshire as a fireman on wood-burning steam locomotives. Herb's father was an engineer for the New Haven, and two uncles also worked for the railroad. His sister worked on board dining cars, and now his son Gary is an engineer on Amtrak's Acela Express. (Courtesy of Doug Scott.)

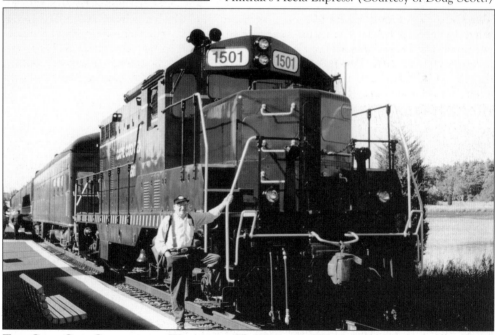

THE CAPE COD CENTRAL AT WAREHAM. The Cape Cod Central Railroad operates scenic excursion and dinner train service on the Cape. The first run, consisting of a single coach between two locomotives, was held on Memorial Day weekend in 1999, and free runs between West Barnstable and Hyannis continued for that inaugural weekend. The 2000 season brought about many changes and some new equipment, including this GP-7, No. 1501. The Cape Cod Central ran a series of chartered trains between Hyannis and Wareham in October 2000, and No. 1501 is pictured at the Wareham station on one of these trips. Fireman Richard "Tink" Tinkham is posing with the locomotive. (Photograph by the author.)

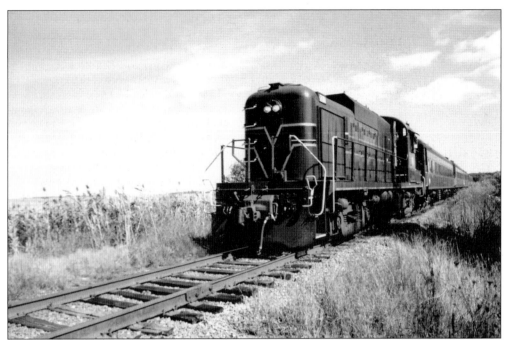

THE CAPE COD CENTRAL RAILROAD. The unique Alco RS-3m, which has an EMD diesel prime mover installed in place of its original Alco diesel engine, is passing through the great salt marshes of West Barnstable in the above photograph, leading a chartered luncheon train in late September 2002. Below, No. 1201 has just run around the train at Sagamore alongside the Cape Cod Canal and is preparing to return to Hyannis. The Sagamore highway bridge looms in the background. (Photographs by the author.)

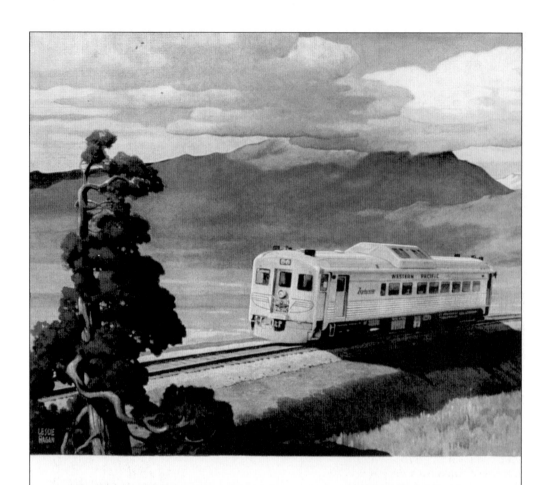

REVOLUTION ON RAILS
This is RDC—the Budd-built, stainless steel, self-propelled rail diesel car. It can operate as a single unit, or it can be coupled with other RDC's to form a train.

It is nimble. It is air-conditioned and wonderfully comfortable. The passenger enthusiasm it arouses attracts new traffic. And it reduces operating costs substantially.

First placed in operation in April, 1950, by the New York Central, 85 RDC's, owned by eleven railroads, are carrying out their varied and frequently difficult assignments in brilliant style.

It is equally at home in hop-skip-and-jump commuter and branch line service, and grueling runs through extremes of climate like the Western Pacific's 924 miles from Oakland to Salt Lake City.

You would be neither a visionary nor an optimist to predict that in RDC the railroads have the successor to the day coach. RDC is one of the most important of the many inventions and developments that Budd has contributed to the advancement of transportation. The Budd Co., Philadelphia, Detroit, Gary.

PIONEERS IN BETTER TRANSPORTATION

A Budd RDC Advertisement. The title of this magazine advertisement from 1952, "Revolution on Rails," sums up what the Budd RDC did for railroads across the country. A plan has recently been proposed to restore rail service to the Cape utilizing this type of Budd RDC equipment, connecting the Cape with Boston-bound trains at Middleboro. (Author's collection.)

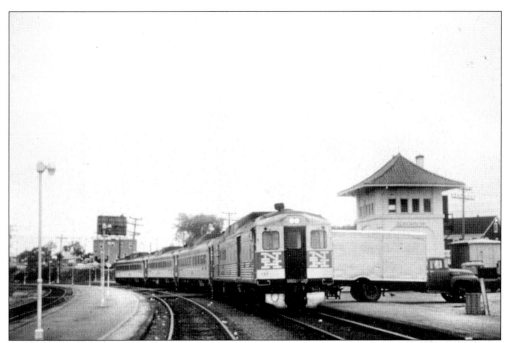

NEW HAVEN RDCS ON CAPE COD.
These two photographs show New
Haven Budd RDCs on the Cape.
Above, a train of four Budd cars is
stopped at Buzzards Bay en route to the
Cape from New York in 1963. To the
right, a special chartered Railroad
Enthusiasts train from Boston to
Hyannis is crossing the railroad bridge
on April 19, 1967. If Cape passenger
rail service is restored with Budd
RDCs, as proposed, scenes like these
could become common once again.
(Above, courtesy of Howard Goodwin;
right, photograph by Kevin T. Farrell,
courtesy of William Reidy.)

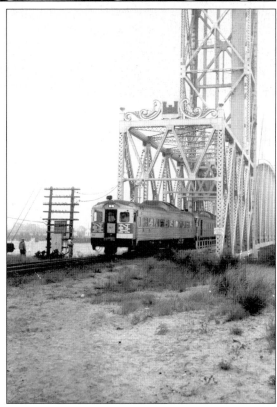

BIBLIOGRAPHY

Burling, Francis P. *The Birth of the Cape Cod National Seashore.* Plymouth, Massachusetts: Leyden Press, 1977.

Farson, Robert H. *Cape Cod Railroads: Including Martha's Vineyard and Nantucket.* Yarmouth Port, Massachusetts: Cape Cod Historical Publications, 1990.

Karr, Ronald Dale. *Lost Railroads of New England,* 2nd Edition. Pepperell, Massachusetts: Branch Line Press, 1996.

———. *The Rail Lines of Southern New England.* Pepperell, Massachusetts: Branch Line Press, 1995.

Lancaster, Clay. *The Far-Out Island Railroad, 1879–1918: Nantucket's Old Summer Narrow-Gauge.* Nantucket, Massachusetts: Pleasant Publications, 1972.

Levasseur, Paul E. "An Old Colony Dude." *Shoreliner:* Vol. 15, Issue 2, 1984.

O'Connell, James C. *Becoming Cape Cod: Creating a Seaside Resort.* Lebanon, New Hampshire: University Press of New England, 2003.

Reidy, William. "The Bay Colony Railroad." *Shoreliner:* Vol. 17, Issue 1, 1986.

———. "Gateway to Cape Cod: Buzzards Bay Bridge." *Shoreliner:* Vol. 16, Issue 2, 1985.

———. "Massachusetts Rail News: The Return of the Cape Codder." *Shoreliner:* Vol. 17, Issue 3, 1986.

Rosenbaum, Joel. "Route of the Cape Codders and Neptunes." *Shoreliner:* Vol. 17, Issue 1, 1986.

Sokolosky, William C. *A History of Railroads in Yarmouth Massachusetts.* Yarmouth Port, Massachusetts: Historical Society of Old Yarmouth, 1975.

Swanberg, J.W. *New Haven Power: 1838–1968.* Medina, Ohio: Alvin F. Staufer, 1988.

Three Centuries of the Cape Cod County Barnstable, Massachusetts: 1685 to 1985. Barnstable, Massachusetts: Barnstable County, 1985.